CHESHIRE
THROUGH TIME
Paul Hurley

AMBERLEY PUBLISHING

Acknowledgements

I would like to thank Linda Clarke of the Cheshire Archives who kindly provided a lot of the old photographs. Others whose photographic scans or assistance may have been used are Ron Frost, Colin McLean, Kevin Greener, Len Morgan, Matt Wheeler, Geoffrey and Delia Wakefield, David Griffiths, Janice Hayes, Mike Edison, Richard Rawlinson, Fred McDowell, Debbie Axson-Hill and anyone else not mentioned but who should be. I would like to thank my lovely wife Rose for her patience during the not inconsiderable time it took to complete the book and for her time spent with me taking the modern photographs and proof reading the end product. All modern photographs were taken by the author, the old ones were taken by an assortment of photographers that we are forever indebted to for without them we would not have this window into the past.

Author Information
Paul Hurley is a freelance writer, author and is a member of the Society of Authors. He has a novel, newspaper and magazine credits. He also has a weekly 60s show on www.redshiftradio.co.uk. Paul lives in Winsford, Cheshire, with his wife Rose. He has two sons and two daughters. You can visit Paul's website at www.paul-hurley.co.uk

Bibliography
Middlewich (with Brian Curzon)
Northwich Through Time
Winsford Through Time
Villages of Mid Cheshire Through Time
Frodsham and Helsby Through Time
Nantwich Through Time

Chester Through Time (with Len Morgan)
Middlewich & Holmes Chapel Through Time
Sandbach, Wheelock & District Through Time
Knutsford Through Time
Macclesfield Through Time

First published 2012

Amberley Publishing
The Hill, Stroud
Gloucestershire, GL5 4EP

www.amberley-books.com

Copyright © Paul Hurley, 2012

The right of Paul Hurley to be identified as the Author of this work has been asserted in accordance with the Copyrights, Designs and Patents Act 1988.

ISBN 978 1 4456 0643 9

British Library Cataloguing in Publication Data.
A catalogue record for this book is available from the British Library.

Typeset in 9.5pt on 12pt Celeste.
Typesetting by Amberley Publishing.
Printed in the UK.

Introduction

This will be my eleventh book in the series; the difference here is that we encompass the whole of this amazing county using the old photographs available to me, so let's start by an overview of Cheshire.

Most of Cheshire is flat, hence the name 'Cheshire Plain', but when we start our tour in Disley and Macclesfield, the land is far from flat and the Cheshire Plain gives way to the Cheshire Peak District as the road passes through the windswept moor on the way to Buxton. This is an affluent part of the county and country for that matter. Wilmslow and its suburbs, Alderley Edge, Prestbury and Mottram St Andrew trip off the tongues of wealthy celebrities and football stars, not to mention the residents of Coronation Street when they want to be posh!

Cheshire is not only a panorama of bewitching beauty today, it drifts through the history of Britain like a gold thread. One of Prince Charles's titles is Earl of Chester because down the ages Chester has been a very important city. Once called Deva by the Romans who settled there and fortified it, it was also home to battles with the Welsh who attacked it from across the border. It is the only remaining walled city in which the walls are intact and make a very pleasant walk for the many tourists who seek its antiquity. The same can be found on the ancient Rows, shops on two levels dating from, in some cases, as far back as the eleventh century.

Sailing ships once came up from the River Mersey to moor on what is now the famous Roodee, and racehorses have replaced ships at the oldest racecourse in England, Chester. Knutsford, with its famous author (Elizabeth Gaskell), has the sole right to append the prefix Royal to the name of its May Day celebrations. Lower Peover is where Generals Patton and Eisenhower planned D-Day. Cheshire can certainly hold its own in the chocolate box village stakes with so many worthy of a visit and too many to mention here.

Cheshire once reached out and encompassed Birkenhead and every town on this side of the Mersey, now, most of the Wirral comes under Merseyside and we have gained Widnes and Warrington, but most of Cheshire's losses were to Greater Manchester. Disley is still in Cheshire, other towns in the area are not so lucky, Stockport, Hazel Grove, Altrincham, Sale, Hyde, Romiley, Stalybridge and Dukinfield have been dragged away to become part of Greater Manchester.

Trains, trucks, cars, and boats, Cheshire in its time has and does boast most of these industries. The dawn of the railway era saw the small village of Monks Coppenhall opened up, when the Grand Junction Railway arrived in 1837 and basically took over and launched the town of Crewe around the railway station. They built the largest railway workshops in the country turning out the steam locomotives that we fondly remember today. Then we have cars and we remain in Crewe again to mention the ubiquitous Rolls-Royce and Bentley cars, the last word in automotive excellence. Rolls-Royce/Bentley motors was based in Crewe at the factory that was built during the last war to build R-R aero engines. In 1946 the R-R Motor Division moved to Crewe manufacturing their bespoke products from then to 1977 when the company went into receivership. In 1971 Rolls-Royce and Bentley had split and eventually Rolls-Royce was bought by Volkswagen and manufacture moved to Goodwood in West Sussex. Bentley was

bought by BMW and remained at Crewe, at least for chassis and bodywork. Another motor company is based in Crewe and that is Whitby Morrison, the world's leading manufacturer of ice cream vans. ERF and Foden HGV manufacturers once shared a road in Sandbach, now they have gone. But look out for the Foden name at traction engine rallies!

As for boats, Birkenhead was famous for shipbuilding through the years but is no longer in the county. Northwich with its firm of W. J. Yarwoods & Sons Ltd who from 1896 to 1966 built 1,000 vessels including coasters, tugs, river and canal boats and small military ships (Lawrence of Arabia spent time there in 1934 designing an RAF rescue craft). Isaac Pimblott & Sons was the second Northwich boat-yard who also built small river and ocean craft including torpedo boats and other warships in the last war. They traded from 1867 to 1974. Both companies have now gone although their products can still be found around the world.

Times pass and all towns go through various phases but it is true to say that not many go through the changes that Northwich has seen and why is this? The answer is Salt. The Cheshire Plain sits astride the country's largest deposit of rock salt. There are three 'Wiches' in Cheshire in which salt has been mined and obtained through the centuries, Nantwich, Middlewich and Northwich. Winsford joined this triumvirate later on. The oldest is Nantwich and at the time of the Domesday Book it had eight 'salt houses,' by the time of Henry VIII it had some 300 salt pits. But by the mid 1800s the trade had declined, the last salt house closed in 1856. Following the Roman invasion, Middlewich was named Salinae on account of the salt deposits around it. The Romans actually paid their troops in salt, hence the name 'salary'.

Then in 1670 employees of the Smith-Barry family were looking for coal in the grounds of Marbury Hall when they came across a seam of rock salt and shortly afterwards salt extraction began. By the nineteenth century it became uneconomical to mine rock salt so wild brine pumping became the get-rich quick plan of the day. Hot water was pumped through the salt deposits and salt was extracted from the water saturated with salt. If you pump water through the salt layer, dissolve it and bring it to the surface a void remains and with nothing to hold up the land above spectacular subsidences took place. Massive chasms appeared underground causing all above to slide into them. This led to the buildings of Northwich leaning at bizarre angles, collapsing altogether or simply sliding into the earth beneath them.

From the 1830s, another source of salt near the River Weaver was needed. This was discovered in Winsford, leading to the development of a salt industry along the course of the River Weaver where many salt works were established. By 1897, Winsford had become the largest producer of salt in Britain. Winsford still supplies the majority of the country's rock salt.

The massive forest of Mara and Mondrem once carpeted vast swathes of the county and leaves us with the picturesque Delamere Forest. One of the largest Cistercian monasteries in the world was built at Whitegate.

Cheshire stretches languidly between ancient and beautiful hamlets and villages, the heavy engineering and dormitory towns for the cities that surround its green and pleasant lands. Canal and railway junctions all pass through, not to mention the modern motorways that bring us up to date. So enjoy the book, the photographs, in some cases the memories and see how things have changed – you will find something different and intriguing with every browse you have.

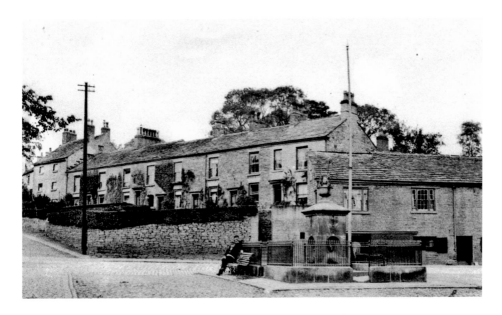

Disley Fountain Square, Undated & 2012

We start off our trip around Cheshire at this farthest outpost, Disley or Distley, anciently spelt Dystelegh-Stanlegh. Its Anglo-Saxon name was Dystiglegh meaning 'windy settlement' or possibly 'wood or clearing by a mound'. It is a Cheshire town that escaped joining Greater Manchester in the 1974 amalgamation. It is actually on the border of Derbyshire and Greater Manchester and has always been between districts and campaigned successfully to remain in Cheshire despite its distance from Macclesfield, the Borough in which it sits. Even as recently as 2008 when the town was to become part of the new Cheshire East unitary authority consideration was given to jump into Stockport Borough or Derbyshire High Peak. A referendum was held with an overwhelming vote to remain in Cheshire. The fountain in the photograph was erected in 1834 by Richard and Thomas Orford for use of the inhabitants. Oh, and David Dickinson had his first antique shop here!

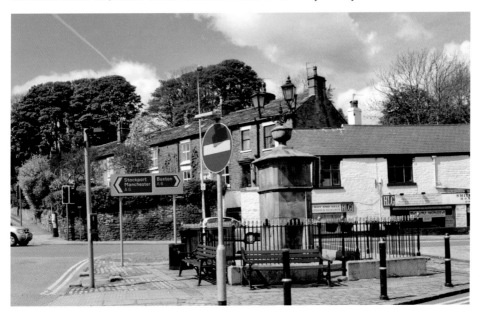

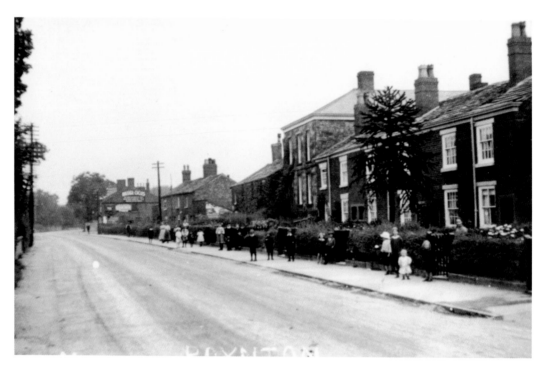

Poynton Midway, Early 1900s & 2012
Situated between Macclesfield and Stockport, in the village of Poynton we see the area of Midway. The town became heavily involved in all businesses to do with clothing, silk and affiliated industries. It was also a mining town with mines owned by the Poynton and Worth collieries that boasted very good and profuse coal seams. Modern Poynton has an intricate traffic system with mini roundabouts set out in attractive coloured stone.

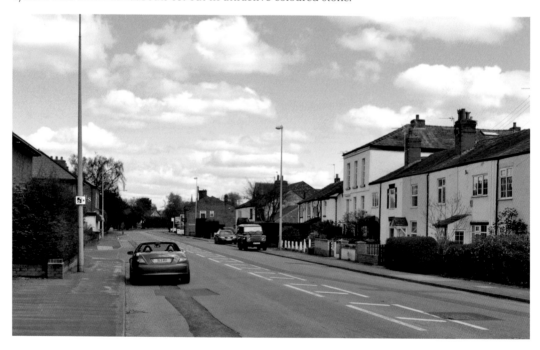

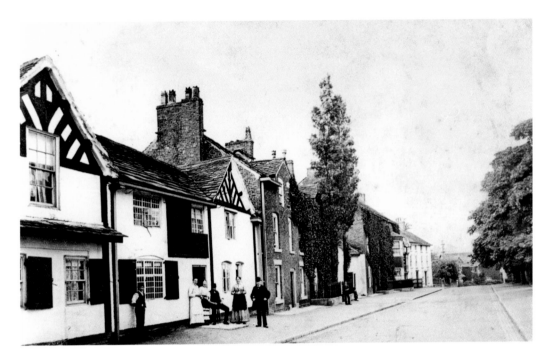

Black Boy Inn, Prestbury, Late 1800s & 2012

Here we enter the beautiful and historic village of Prestbury to look down the main street past the Legh Arms on the left. The pub dates from around 1580 and it was to be called the Saracen's Head. An itinerant painter was to paint the Saracen's Head name board. With a mix up in translation he painted a black boy on the board. The pub became known as the Black Boy or Blackamoor's Head. In 1605 it was known as the Legh Arms after the landowners, the Leghs of Adlington Hall and in 1900 it was the Black Boy Inn. It is now a very attractive pub restaurant with accommodation called The Legh Arms and Black Boy Inn, although in these days of political correctness, it is not known how long that name will remain.

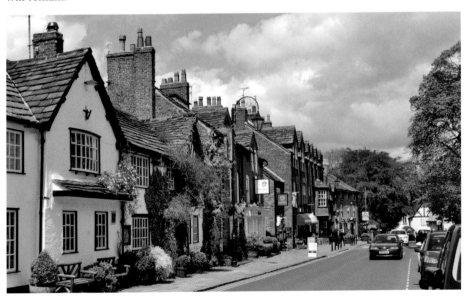

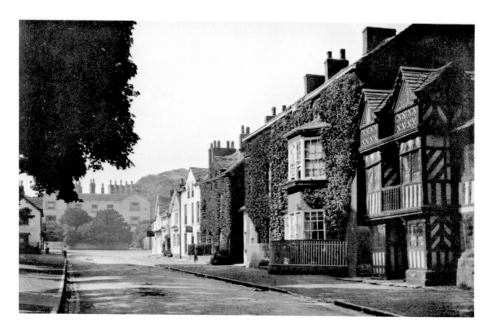

Prestbury Village, Mid-1900s & 2012

We pass the pub now and look back from the opposite direction with the Tudor building on the right. More on this later, but it must be stated that Prestbury as well as being a quintessential English village is also one of the most affluent in the country. It is the home of wealthy footballers, celebrities and business residents. Now back to this ancient black and white bank building, it dates from around 1580 and was the residence of the vicar of the parish across the road. There is a plaque on the wall that tells us that during the Commonwealth the church was closed and the vicar preached from the balcony. This balcony was also used as a pulpit during periods of the plague and 'sweating sickness'. It was opened as a bank in the early 1920s and still serves that purpose today.

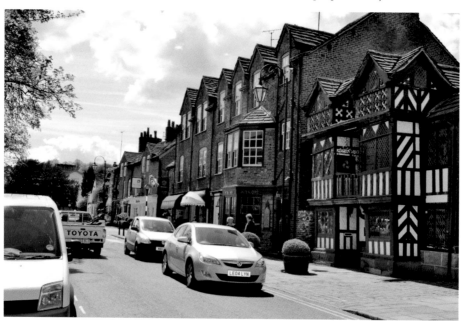

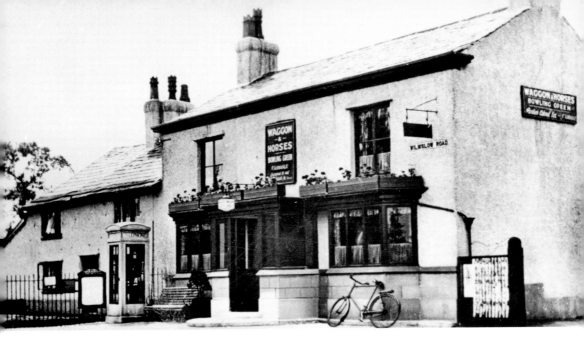

Wagon & Horses Handforth, 1930s & 2012

The Wagon & Horses pub is on the cusp of Stockport and Wilmslow actually in Wilmslow Road. The old and new photographs are vastly different as the pub has been upgraded over the years. I have dated the old photograph by virtue of the fact that there is a K3 telephone box outside. These boxes were introduced in 1927 and were made from pre-cast concrete instead of cast iron, hence, there are very few left now despite 12,000 being erected around the country.

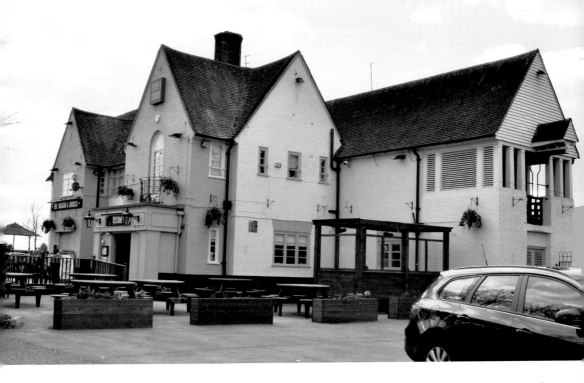

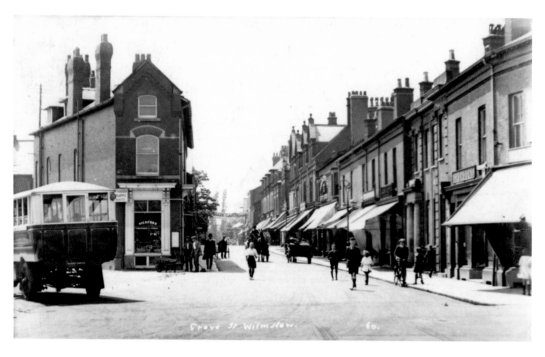

Wilmslow, Grove Street, 1920s & 2012

I have dated this old photograph in the 1920s although it could have been a little earlier, but I think it is more likely that the bus with the solid tyres was old even then. The bus is just within Green Lane and at the time would have been outside the police station that was situated there. The police station was far too small and not fit for purpose having been built for very few officers under a police inspector. After being relocated some years ago the building spent time as a pub called the Blue Lamp and was then demolished. As can be seen, little has changed in this view over the eighty odd intervening years.

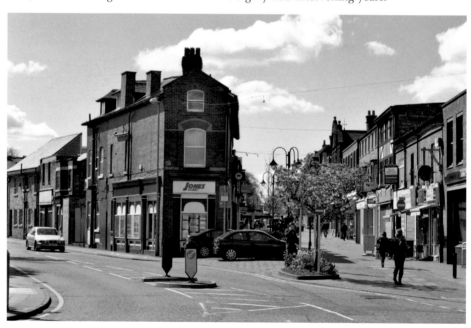

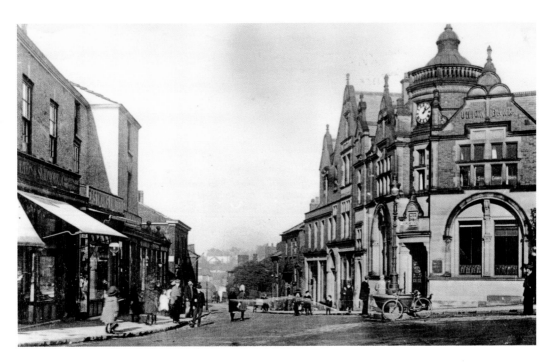

Wilmslow, Bank Square, 1920s & 2012

This area, also known as Bank Square, shows Eastman's butcher's shop on the left and the Union Bank of Manchester opposite. Ahead is Church Street, which leads to Wilmslow parish church. Since the old photograph was taken, much rebuilding has taken place. The bank is still there but is now a public house called the Boardroom.

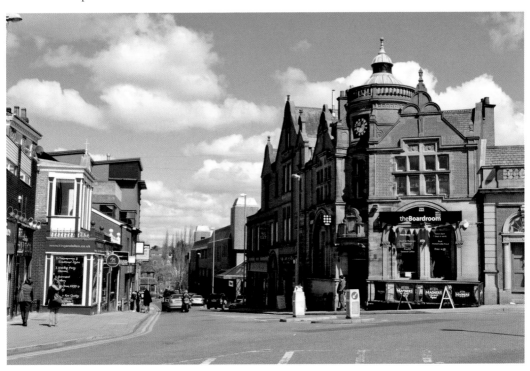

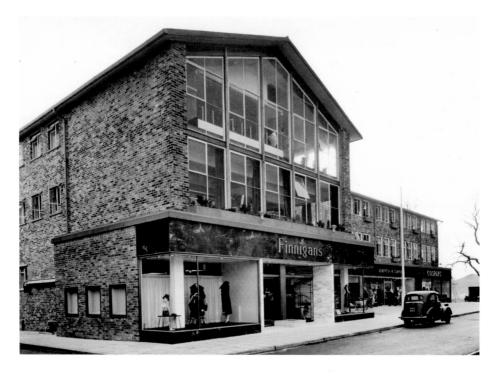

Wilmslow Shops, Alderley Road, 1950s & 2012

This large department store building has seen some re-modelling over the years. In the old photograph with the Ford Anglia outside the business was Finnegan's store with other shops alongside. It is now part of the Hooper's high class department store that includes the shops in the distance and the buildings out of site on the extreme left.

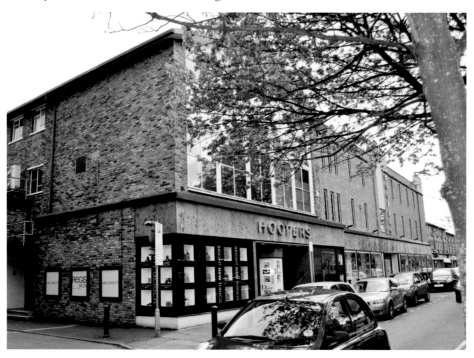

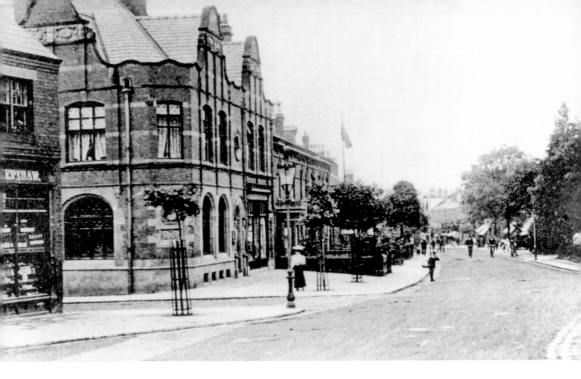

London Road Alderley Edge, 1800s/1900

With Edward Kershaw's chemist on the left we look down London Road towards the station. The town was created as a result of the railway connection. It attracted, even in those long gone days, the wealthy business commuter traffic to and from nearby Manchester. High quality housing was built and this remains the case with one of the most exclusive post-codes in Britain.

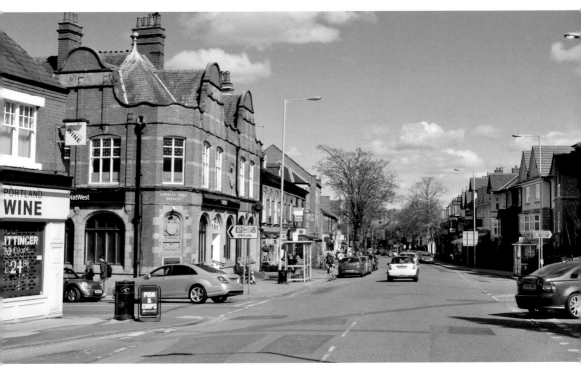

Bollington Aqueduct, Early 1900s & 2012

The Macclesfield canal was built quite late for the canal age in 1826 and joined the Peak Forest canal to the Trent and Mersey canal a distance of 26 miles. It was built by Thomas Telford and had two aqueducts, this one being the largest. It is very popular and busy now being part of the Cheshire Ring. In the old photograph we see a man in uniform. In those days police and the GPO had similar uniforms with shako hats. The man could be one of the Canal Police who patrolled the tow paths and canal property.

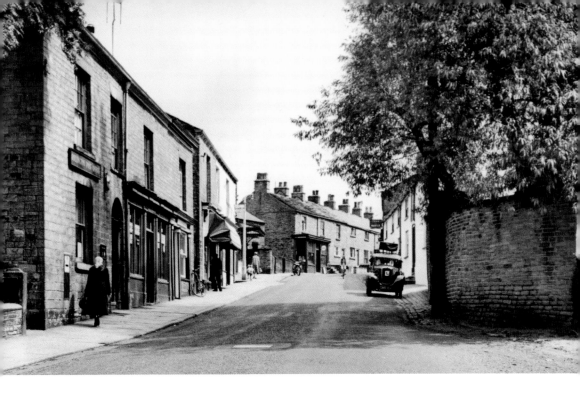

Bollington Palmerston Street, 1940s & 2012

Palmerston Street is named after Lord Palmerston who was Prime Minister in 1855, which was round about the time that most buildings there were erected. The canal was cut around the same time and will have been a catalyst for the buildings around it. Palmerston Street was always a busy shopping street and in the 1930s the Empire picture house was here. In the old photograph we can see Bollington post office on the left. It is now a private house.

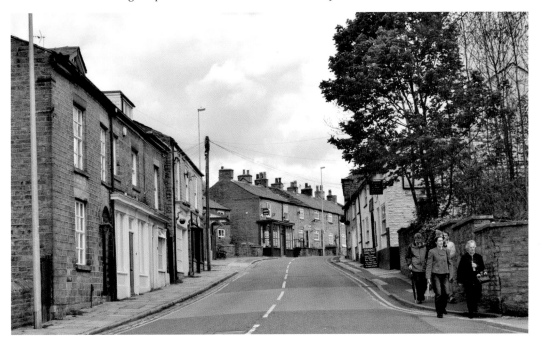

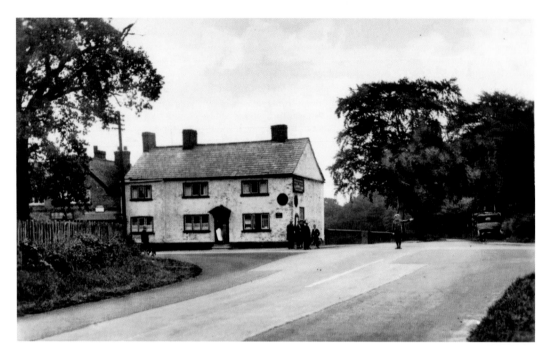

Monks Heath Crossroads *c.* 1915 & 2012

This crossroads is situated on the roads to Alderley Edge, Macclesfield, Congleton and Knutsford. We walk into Congleton Road and look across at the cottages that have been there for many years. The sign on the wall says 'Aked & Pott'. This was a refreshment stop called The Cyclist's Rest, for travellers on this intersection. Aked Pott & Goodwin Ltd of King Edward Street Macclesfield manufactured mineral water, cordial and bottled ale and porter.

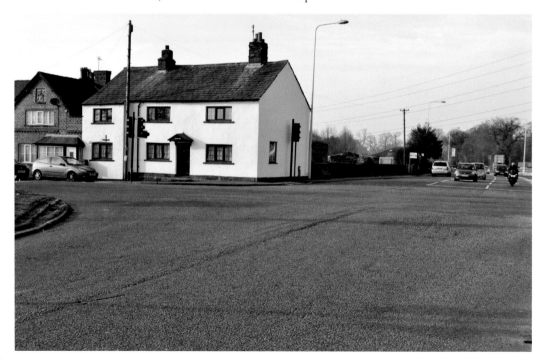

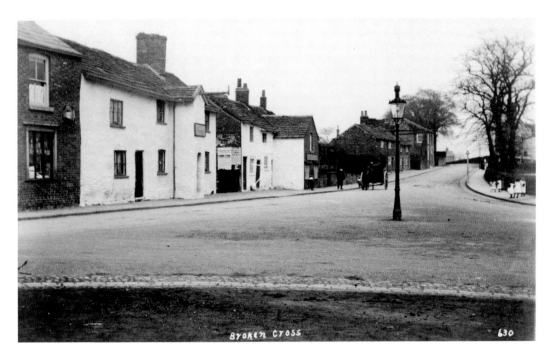

Broken Cross near Macclesfield, Early 1900s & 2012

At Broken Cross we look towards Macclesfield with the Bulls Head pub on the left. As can be seen, there have been some alterations to the front of the pub and the buildings around it over the years. There is a remodelled front and the roof has been modernised. The lamp standard is still in the centre of the carriageway albeit is a more modern one.

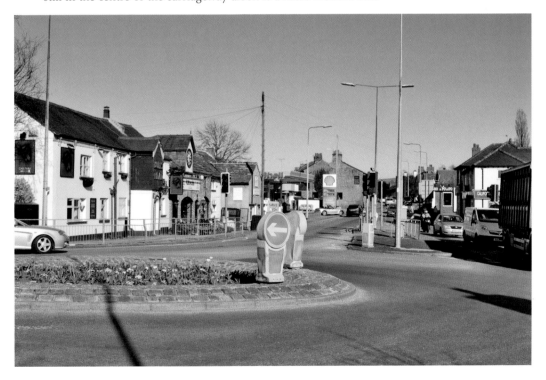

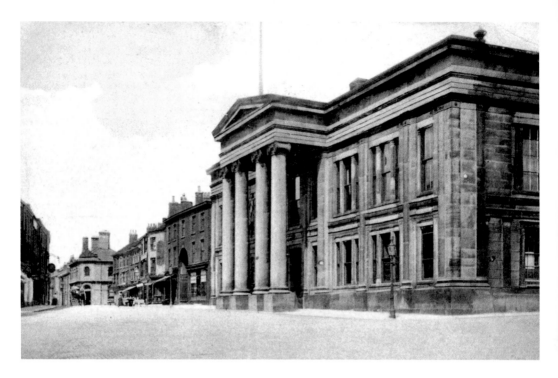

Macclesfield Town Hall *c.* 1900 & 2012

This handsome building, built of stone in a classical Grecian style in 1823 to 1825 stands majestically in the market place. It was enlarged and new fronted in 1869 to 1870 and housed the magistrates' court, the Borough Police Headquarters and, in 1896 William Sheasby was the chief constable. Strangely, in 1934 Henry Sheasby was shown as the chief constable and his home address was 151 Chester Road. It had a large assembly room and on the ground floor a butter and corn market.

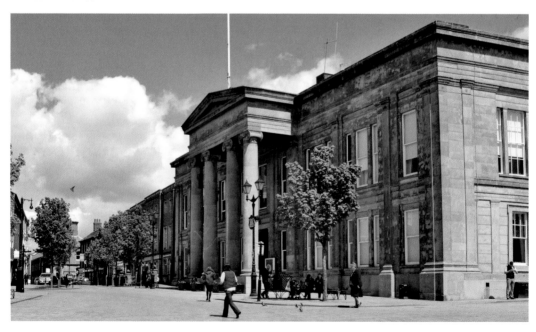

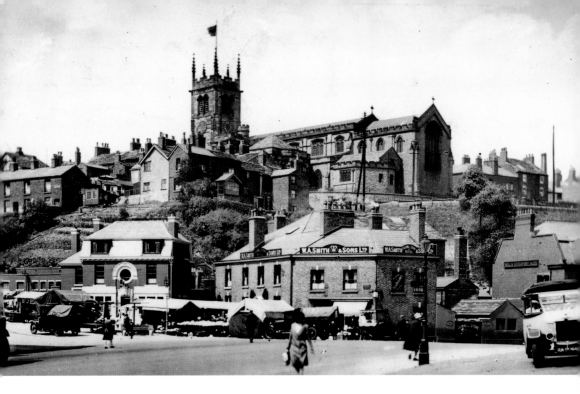

Waters Green, Macclesfield, 1920s & 2012

This very pleasantly named area of Macclesfield has always been a favourite gathering place with its assorted and cosy public houses. In these two photographs, the reader can become immersed in old Macclesfield with so many things that have not changed to compare and enjoy. A painting depicting the building of the pub with the round window is displayed in the West Park Museum.

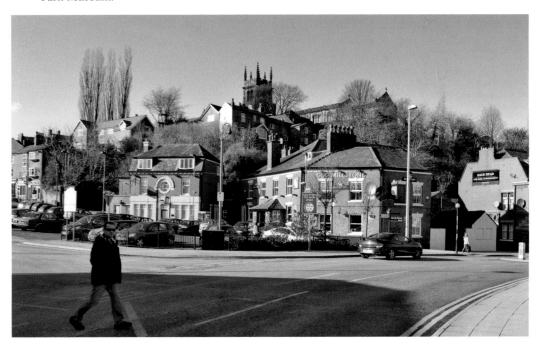

Modern School Macclesfield, Mid-1900s & 2012

These buildings were opened in 1844 as a Modern School to run in tandem with the grammar school. Land from the Kings School was sold in order to purchase and build this school at the junction with Bridge Street. In 1910 the grammar school in King Edward Street was combined with this modern school under the name Kings School. This building is now used by community agencies and the grammar school building as dwellings.

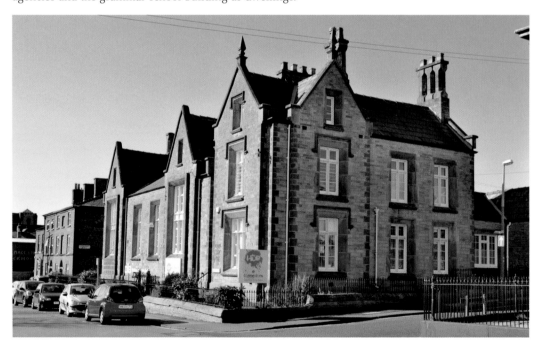

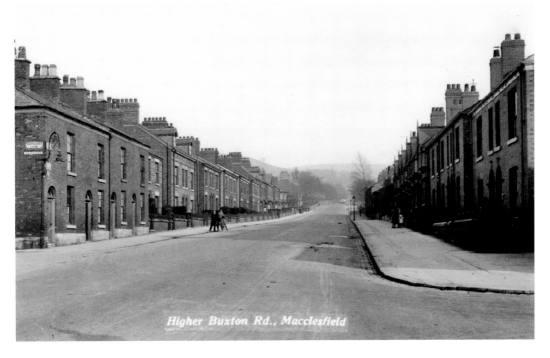

Higher Buxton Rd., Macclesfield

Higher Buxton Road Macclesfield, Mid-1900s & 2012
Continuing up Higher Buxton Road in the direction of Buxton and the Cheshire Peak District through which you travel to get there. Little has changed here in the intervening years other than the increase in traffic.

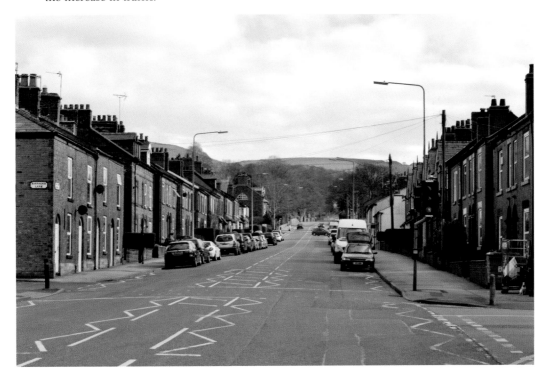

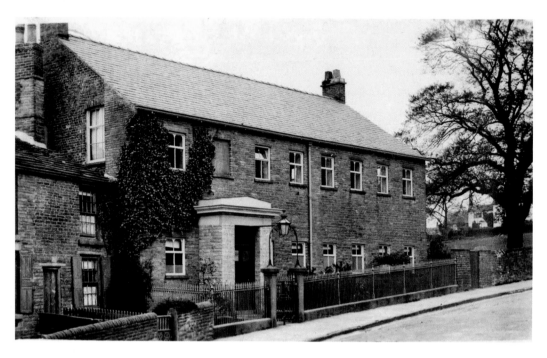

Hurdsfield Sunday School, Early 1900s & 2012
This attractive building was built as a Nondenominational Sunday School in 1811 and was enlarged and improved in 1833. It is still in use as a Sunday School and church. Little has changed in the intervening years, at least to the outside of the building, apart from a sloping porch roof. Houses have been built next door.

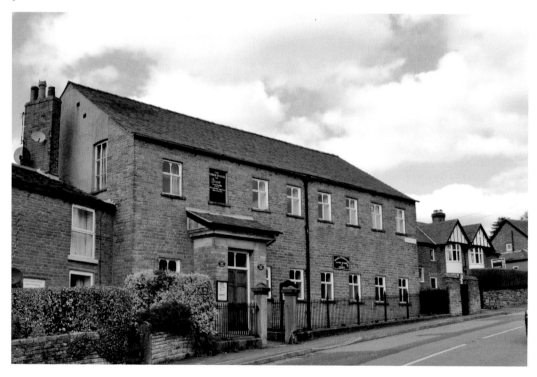

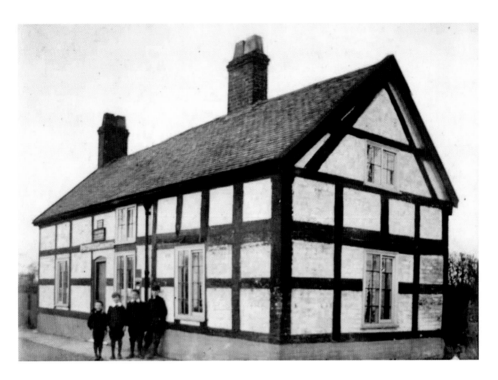

Gawsworth Post Office, Early 1900s & 2012
We now reach Gawsworth, one of the most beautiful villages in Cheshire and this old post office building is situated on the Congleton Road crossroads. The village houses Gawsworth Hall, a beautiful Tudor Mansion with an outdoor theatre.

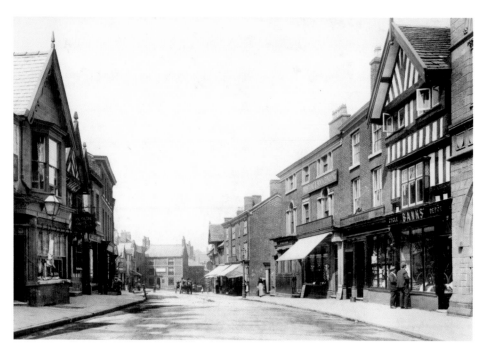

Congleton High Street, 1890-1900 & 2012

A look now at the busy market town of Congleton that has vastly changed over the years, with a new bypass and road network. Fortunately some streets have remained the same and the High Street is one of them. On the far right we can see the end of the town hall, the inset shows this attractive building which was built in 1864 on the site of an older town hall. Like others from this era, the ground floor was once the market with the magistrates' rooms, municipal offices and courts above.

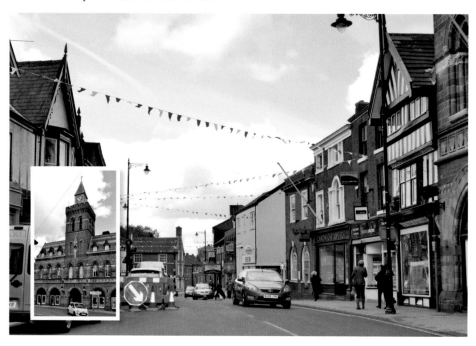

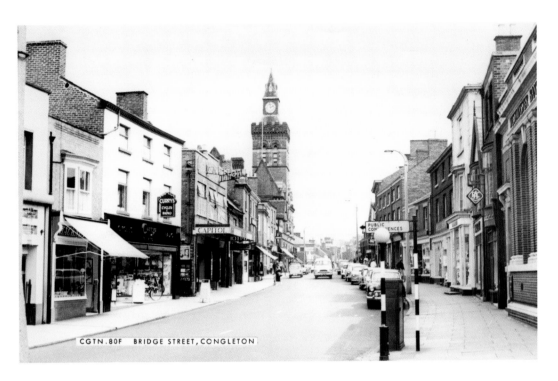

CGTN.80F BRIDGE STREET, CONGLETON

Congleton Bridge Street, 1950s & 2012

The postcard is marked Bridge Street but was actually taken from Bridge Street into High Street and the town hall can be seen in the distance. Note that the Capitol Cinema now houses Capitol Walk. It is an atmospheric snapshot of a 1960s street scene dated by the Minivan and the Ford Anglia 105E, both 1960s vehicles.

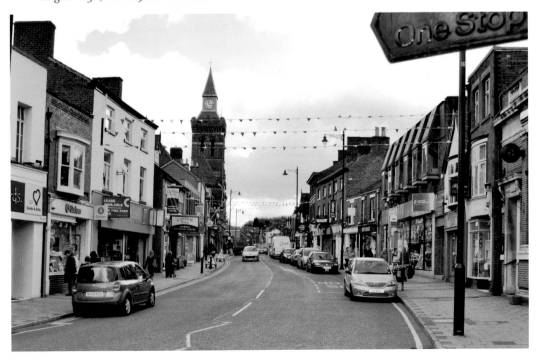

Sandbach Black Bear, 1960s & 2011

Now in Sandbach this ancient pub is one of the town's oldest inns dating from 1634 as the sign above the door indicates. It is situated on the edge of Market Square, a cobbled area famous for the Sandbach crosses that can be found there. The market place also boasted the town hall until 1889 and still has two more public houses. For many years this held the regular Sandbach market.

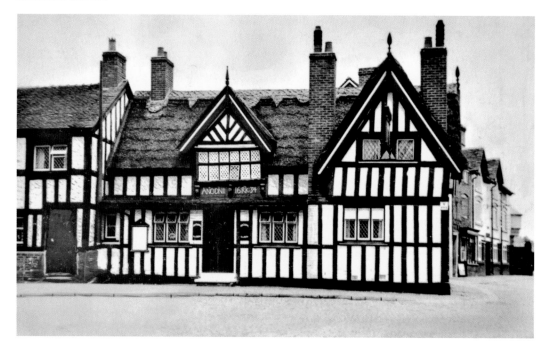

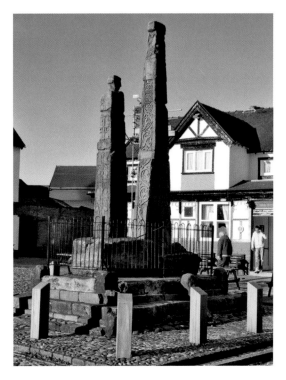

Sandbach Old Crosses, 1920s & 2011
Apart from the now defunct Foden and ERF wagon companies, we look at what Sandbach is really famous for and they are the ancient crosses on the Square. In the old photograph we see a man relaxing upon the steps with the Crown Hotel in the background. The Crown Hotel dates from the 1680s and still serves the community as does the other pub on the square, the Market Tavern.

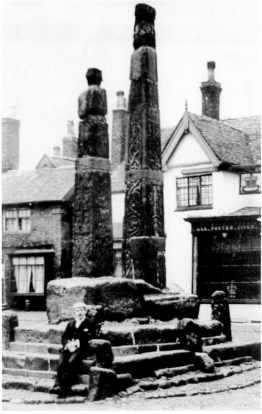

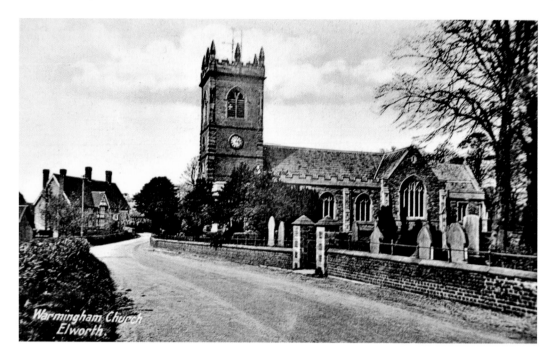

Warmingham Church, Undated & 2010

The church is dedicated to St Leonard and like the church at Holmes Chapel was originally timber framed with a brick tower dating from 1715. The whole church was re-built in stone in 1870 by the architect Richard Charles Hussey. Twenty years later the windows in the tower were replaced with windows in the Gothic style.

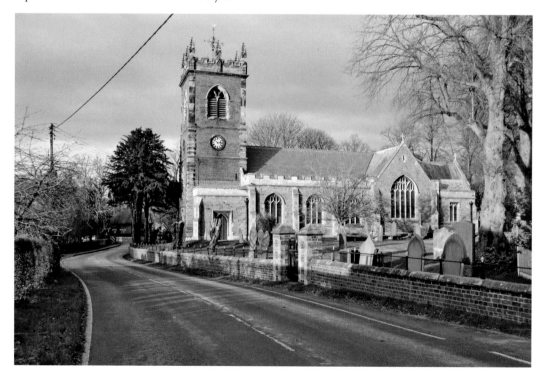

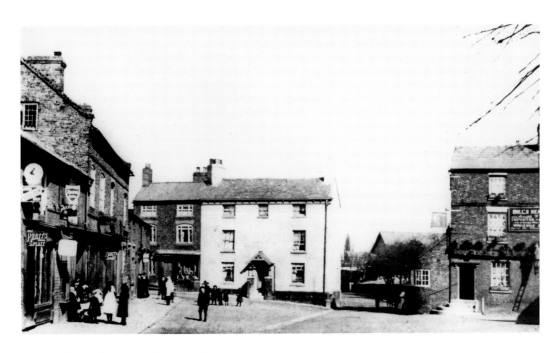

Holmes Chapel, Early 1900s & 2010

Here we have a look at Holmes Chapel back at the turn of the last century. The George & Dragon, centre left later gained a black and white façade before being demolished and the new George & Dragon built further back. The Bulls Head on the opposite side of the road can clearly be seen. In 1902 Johnson Joseph Whitney was the licensee and this pub housed both US servicemen and Italian prisoners during the last war. It was then demolished in 1948 for the first attempt at road widening.

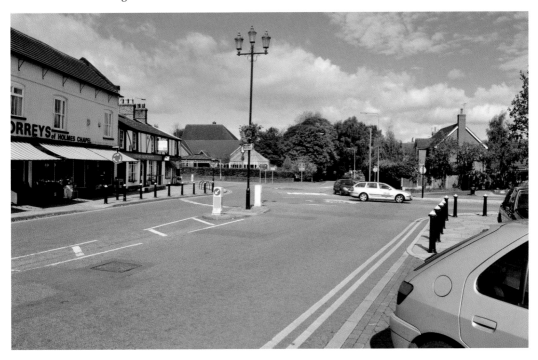

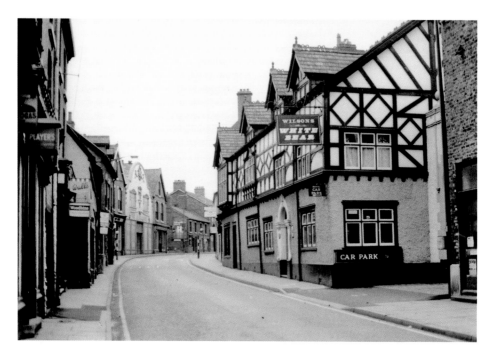

Middlewich White Bear, 1950s & 2010

On the right we see the White Bear and further along the Black Bear Hotel. At this end of Wheelock Street was the Bullring and here up until the mid-1800s bear baiting took place, hence the names. An old local poem goes: 'Scarce any man ever went sober to bed, 'Tis quite dreadful to think the lives they all led, At that time in Cheshire no fun could compare With the sport of all sports, namely, baiting the bear.' In the distance can be seen that Alhambra, built originally as a cinema during the 1930s, a highly decorated front elevation in the rather loud style of cinemas built over the period. It is now a Chinese restaurant.

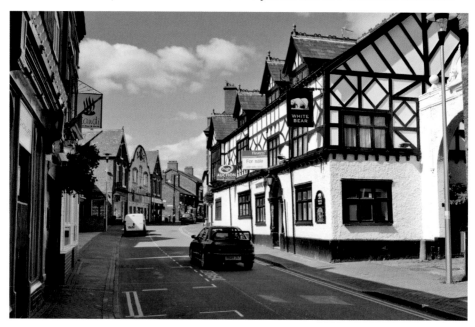

Middlewich from The Church Tower, 1950s/60s &2010

Demolition has not started on the opposite side of the road as the Vernon Cooper store is still there. The shop next to the butcher's/Indian restaurant on the left has been built with an overhang that is no longer there. These photographs illustrate what had been there for a very long time but has now gone. Many thanks to the vicar who demonstrated to me just how unfit I am!

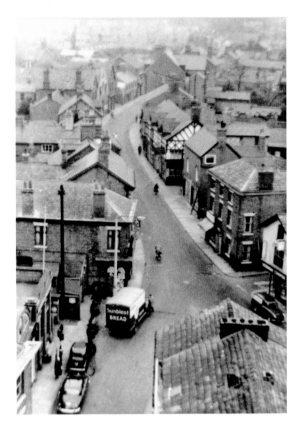

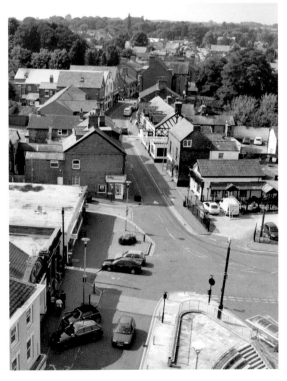

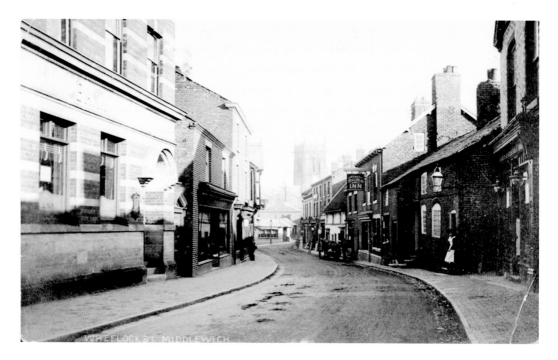

Middlewich Towards The Bullring, *c.* 1900 & 2010

This old photograph is filled with period charm and looks towards the Bullring with the buildings that were once situated there. The Bulls Head pub can be seen on the right, this was opposite the White Bear and was one of the buildings that was demolished and replaced with a similarly shaped new one a short while ago. Note the single storey building next to the bank. It has been altered with faux black and white beams.

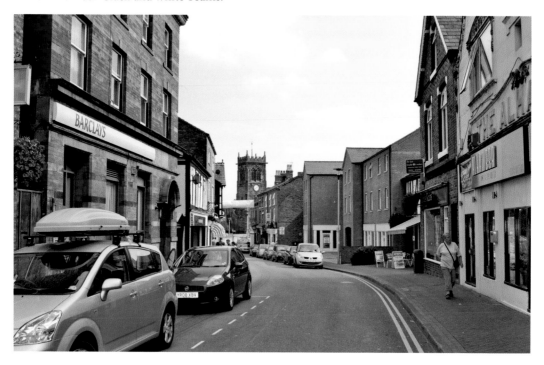

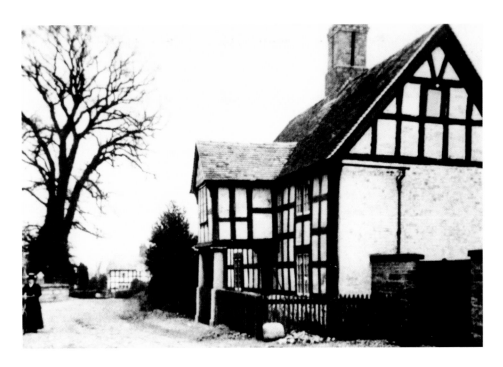

Church Minshull, 1900s & 2012

Now on the road from Nantwich to Winsford we reach the pretty village of Church Minshull. Black and white buildings predominate and the photographs show Church Farm, which is opposite St Bartholomew's church. The building has a 'Magpie Porch' and at one time was the vicarage. It is believed that it was once the home of Elizabeth Minshull, the third wife of the poet John Milton. They married on 24 February 1663 and he died in 1674. She was thirty years his junior and lived to the age of eighty-nine.

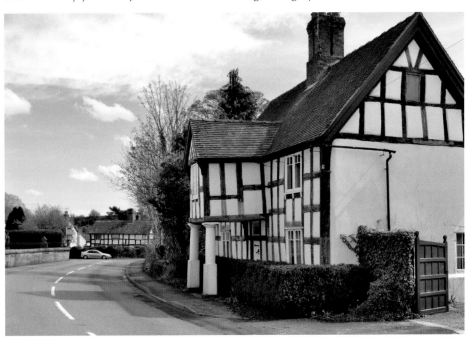

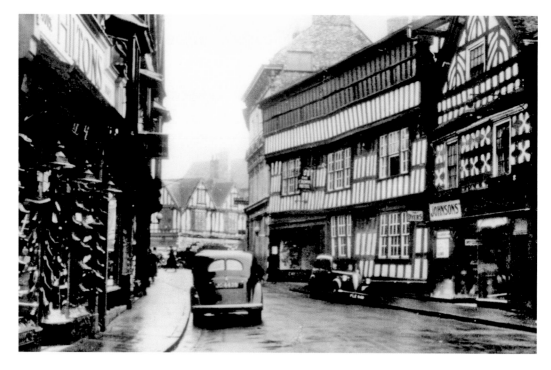

Nantwich High Street, 1950s & 2010
Having walked down Nantwich High Street past the ancient Crown Hotel, we turn and like the 1950s photographer, take a modern photograph. The Crown Hotel has changed little since the 1950s but then it has been there since just after the great fire in 1583! Once the principal hotel in the town, it is possibly one of the most original Elizabethan buildings to be found anywhere. In 1902 the licensee was George Piggott, said to be an ancestor of jockey Lester Piggott. It was built on the site of an earlier inn, the Crowne that burnt down in the fire.

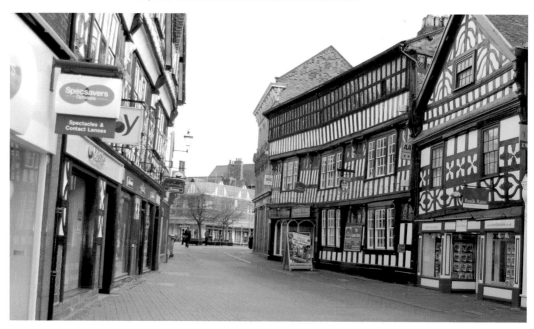

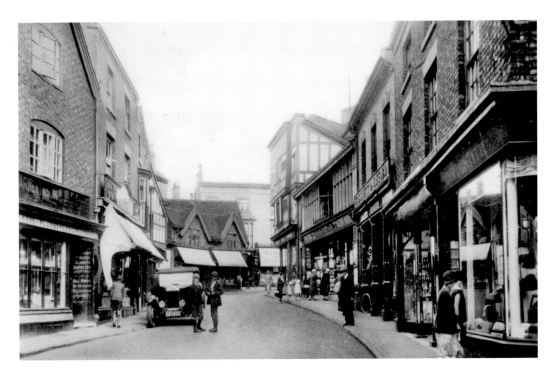

Nantwich High Street, 1920s & 2010

In this photograph we see lower High Street as it reaches the junction with Water Lode and the buildings updated. In the modern photograph all the buildings on the left have been rebuilt. The twin hipped block of shops in the distance have been demolished for road widening and the White Pub behind them at number 15 is still there. Underneath the roof in the old shot it says Burton Marston's. It is called the Union, in 1935 it was the Union Vaults and in 1906 it was simply listed as Harry Young, licensed victualler, wine & spirit merchant and bottler.

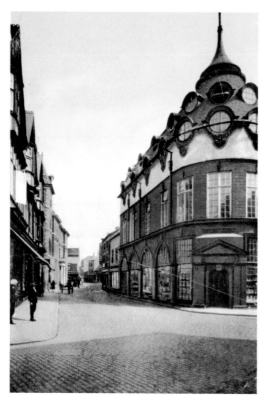

Hospital Street 1923 & 2010

Situated at the end of Hospital Street is a 'wedding cake' of a building housing Clive Christian's luxury Furniture Company.

The new building, built in 1911 was not to everyone's taste and was designed by local architects Bower & Edleston. Whatever the locals said at the time of construction, this has to be described as a beautiful building and asset to the town.

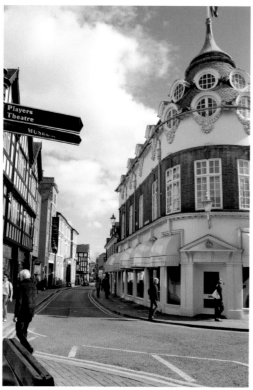

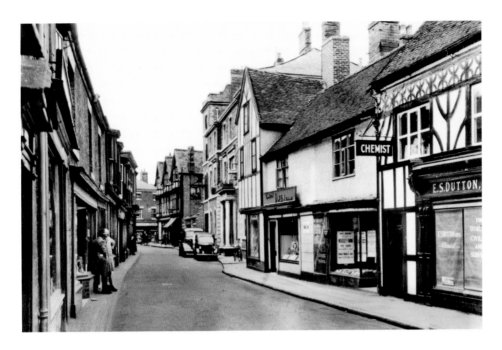

Hospital Street, 1950s & 2010

Hospital Street is believed to have been named after St Nicholas Hospice established in 1083 and situated at the other end. The present house incorporates a sixteenth-century dwelling and the birthplace of Randulf Crewe, Lord Chief Justice in 1625. On the right with the Palladian pillars we see the Lamb Inn or Chatterton House as it is called. In the 1800s it was known simply as Lamb Family & Commercial Hotel. It's no longer a hotel as it was converted to apartments, shops and a restaurant in 2004/06 after a long period of neglect. An inn has stood on this site since around 1554 and was the headquarters of the Parliamentary troops during the English Civil War.

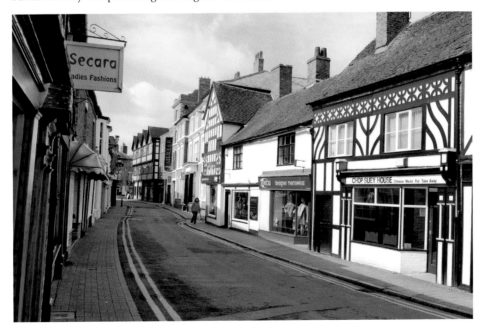

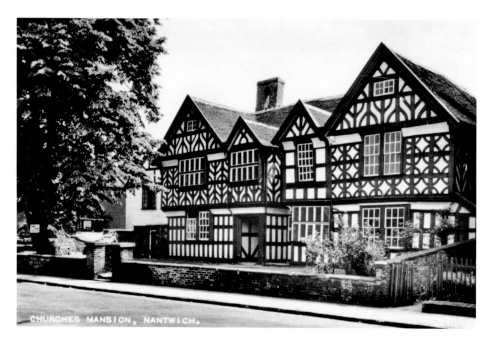

Churches Mansion, Undated & 2010

Churches Mansion was built in 1577 and as such is one of the oldest buildings in Cheshire. It escaped the Great Fire which, had the fire travelled further, would have meant this ancient building only lasted six years! It was built by Richard Churche who was born in 1540 and married Margerye Wright, the daughter of another important family in the town. Richard had come from Leicestershire, become wealthy and had the mansion built for him by Thomas Cleese or Clease, a master carpenter who also worked at Little Moreton Hall. It has had various uses over the years and is at the time of writing an antique shop.

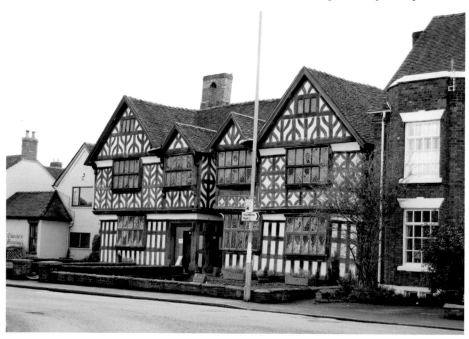

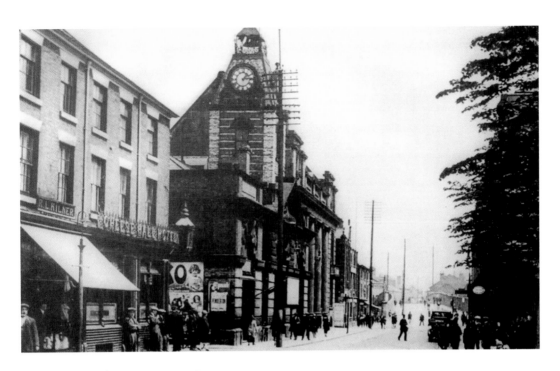

Crewe Earle Street *c.* 1920 & 2012

Earle Street once stretched from the town centre across the railway bridge but many alterations have taken place in the area and the end of it has been bypassed. The large building with the clock houses the indoor market and further along are the municipal buildings. Little has changed over the years. The Cheese Hall Hotel has reverted to the name Cheese Hall after a while spent as the Three Lamps. The pub backs on to the attractive old Lyceum Theatre, still providing live entertainment to visitors from far and wide.

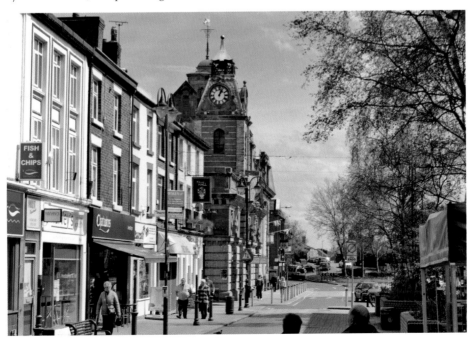

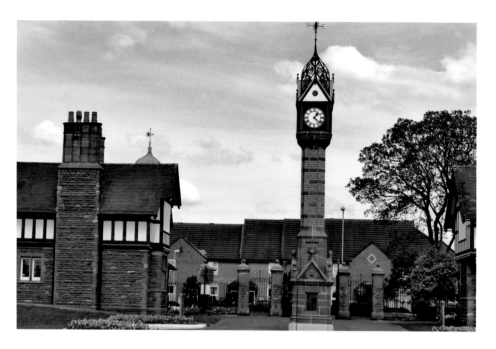

Crewe Jubilee Clock c. 1905 & 2012

Queens Park Crewe, one of the loveliest municipal parks in the country that underwent a complete overhaul in 2011 and was formally opened again in September of that year. It was opened originally with great ceremony by HRH The Duke of Cambridge on Saturday 9 June 1888. The park was donated to the town by the London & North Western Railway Company and was to celebrate both the Golden Jubilee of Queen Victoria and the 50th anniversary of the Railway's involvement with the town. There are many interesting facts worth researching with regard to the two lodges in the photographs. One is that they were built from the sandstone that was removed during the cutting from Edge Hill to Lime Street Station in Liverpool.

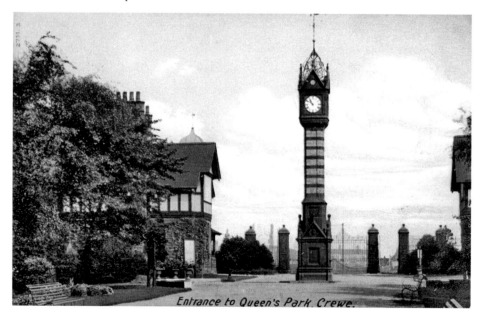

Entrance to Queen's Park, Crewe.

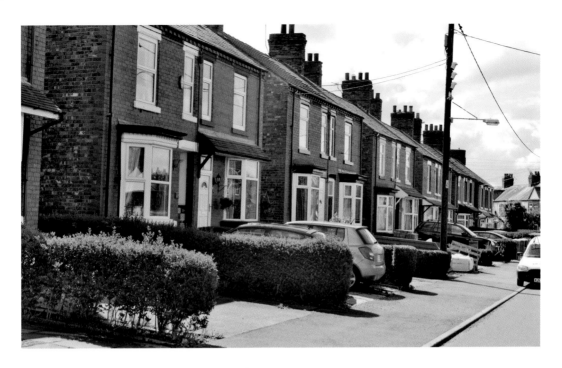

Haslington Primrose Avenue *c.* 1910 & 2012

This very atmospheric photograph was taken in the Crewe suburb of Haslington and is a pleasant way to compare a suburban street and how it has changed over the years. In this case not very much. The children in the old photograph seem to be setting off for a fête or perhaps just playing at being in one. But look at the houses behind them in the two matching photographs, note the white tinted bricks in the nearest gable end in both 2012 and the early 1900s and see that they identify the shots.

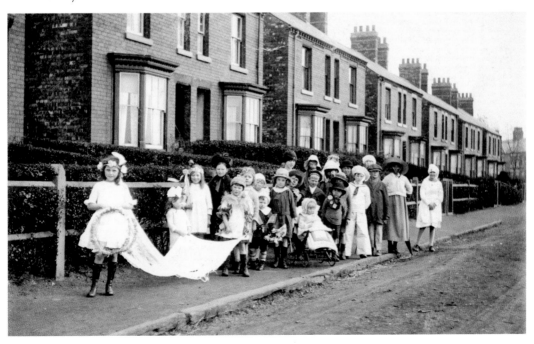

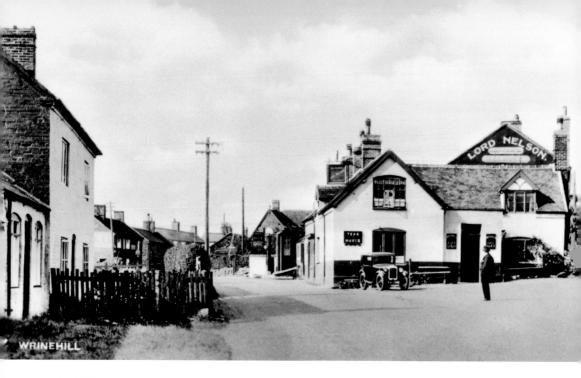

Wrinehill *c.* 1920s & 2012

You purists out there will say that Wrinehill is on the Staffordshire border and I would have to agree with you. It has, however, got a Crewe postcode and is listed as being a suburb of Crewe. This old photograph shows the excellent pub, now called the Crown Inn, which in days past was the Lord Nelson. The village was once called Checkley-cum-Wrinehill. So if you decide that technically it is in Staffordshire, just enjoy the photograph with its charming Austin Seven.

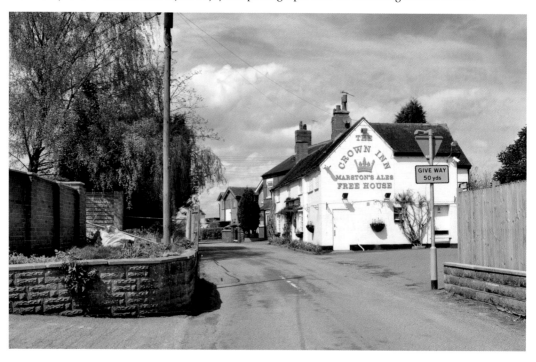

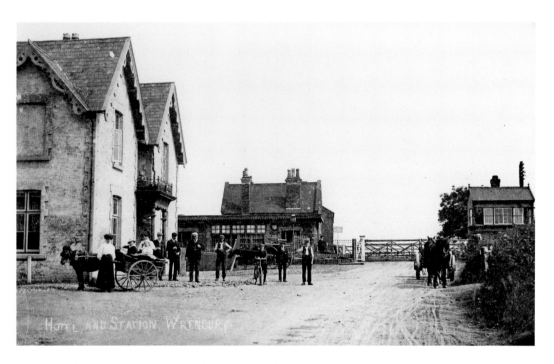

Wrenbury Salamanca Inn and Railway Station *c.* 1900 & 2012

Once known by its full title Wrenbury-cum-Frith is situated 5 miles south west of Nantwich. The railway crossing gates are in the picture and are situated at the end of the station platform. The large double-fronted building on the left was once the Salamanca Inn and Hotel, and a cattle sale was held here on the second and last Monday in each month. In 1896 the sale yard which adjoins the station was enlarged and improved. In 1900 Mrs S. T. Cooke was the licensee. Now a private dwelling, it is a credit to its owners.

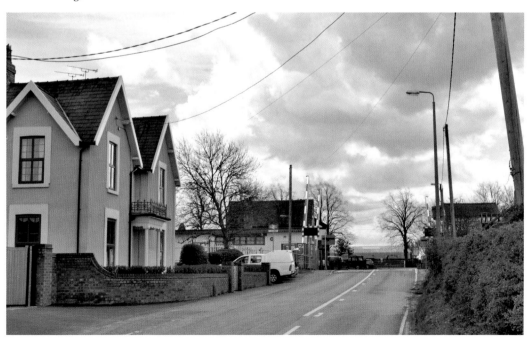

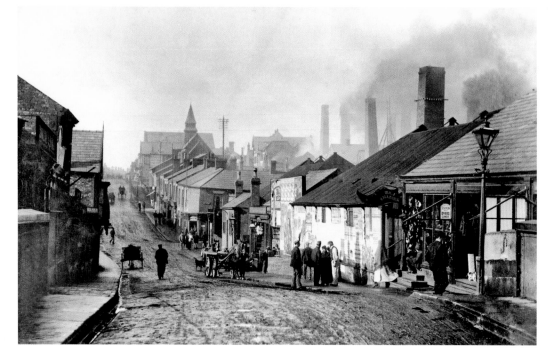

Winsford (Dark Town) 1893 & 2012

The old photograph gives an insight into the awful conditions that existed in Winsford in the 1800s and 1900s and why it was nicknamed 'Dark Town'. The photograph taken from the town bridge gives some idea of what the residents of this part of the town lived through. The smoking chimneys stretched all along New Road to Meadow Bank. The 2012 photograph is of green trees and blue sky, something that the people of this area in 1893 seldom saw.

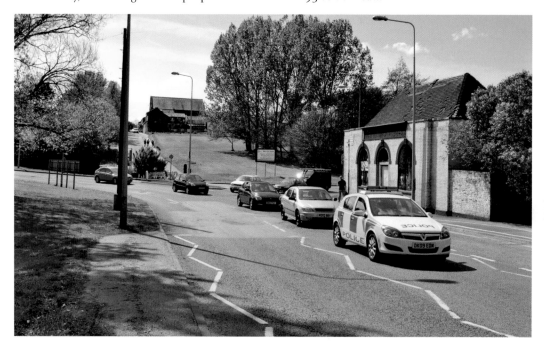

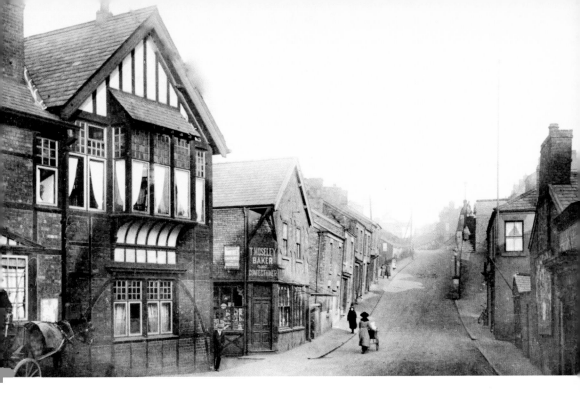

Winsford Wharton Hill, 1890 & 2009

Sometimes called Winsford Hill, sometimes Wharton Hill this road from the town bridge to Northwich was at one time built up and busy. The more famous Winsford Hill is the one in Winsford, Somerset, so Wharton Hill is the more appropriate. The lady with her pram would not be able to push it up the road today, not safely anyway.

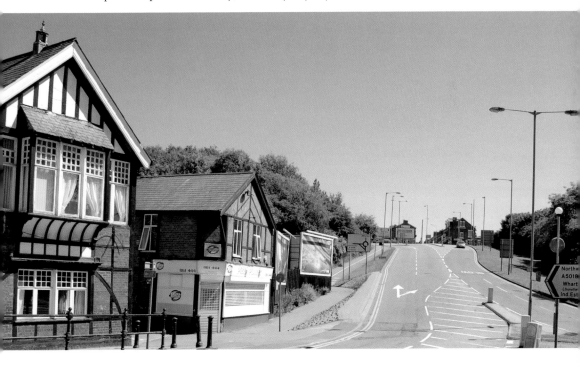

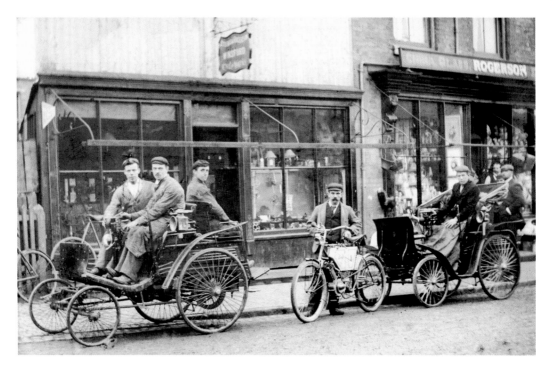

Winsford High Street, 1895-1905 & 2012

This old photograph is of what must have been some of the very first motor cars in Winsford. They are pictured in the High Street outside what is now High Street Garage. When the old photograph was taken it was Stubbs & Rogerson Cycle Works, the shop next door is Rogerson's china and glass dealer. This shop went on to house Harris Furniture, Auto Spares and the strangely named Livvy's Tom Baby World, which is now a second-hand shop called This-n-That.

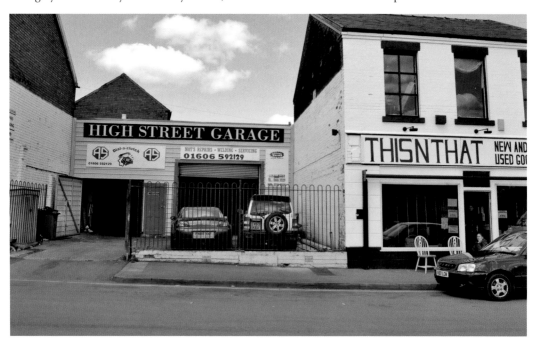

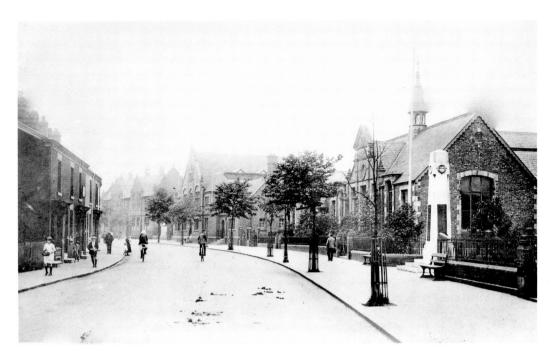

Winsford War Memorial *c.* 1920s & 2012

This area has changed dramatically through the years but the main red brick buildings still stand proud. The war memorial remembering the dead of previous wars will have been quite new when this photograph was taken. It was unveiled by Colonel Sir George Dixon, Chairman of Cheshire County Council, on 18 September 1920. It now stands in the town centre after suffering vandalism in the 1970s.

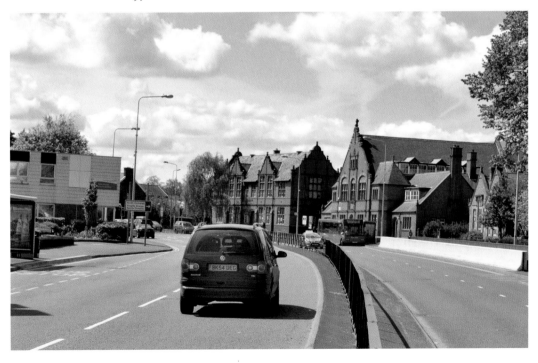

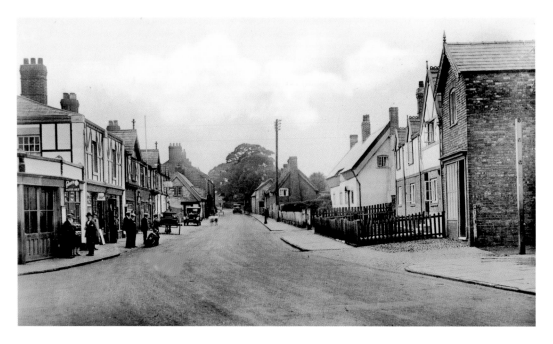

Delamere Street Winsford c. 1920s & 2009

We now stand on Over Square roundabout and look into Delamere Street. The 1920s view has changed little from today, the buildings in the foreground are still there but the large white cottage on the right was demolished and became Dickinson's car showroom and petrol station; the latter remains, but a Spar store has replaced the car showroom.

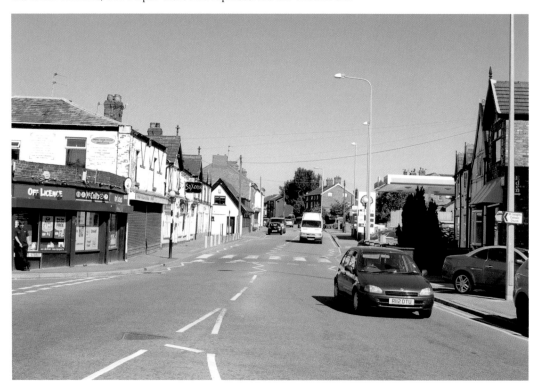

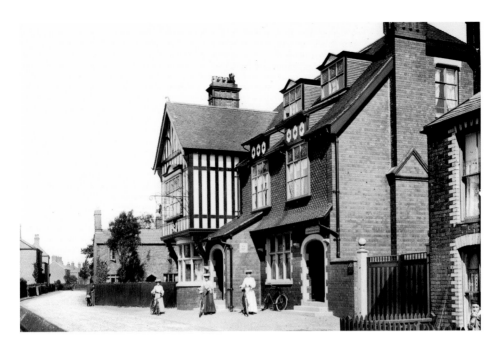

Moulton, The Lion Pub 1896 & 2009

Until 1894 Martha Lyon, whose married name was Jackson ran a grocer's shop and beerhouse on the site, prior to this her husband had operated the business. Being an entrepreneur, Martha had the present public house built and named it appropriately 'The Lion,' with a subtle play on her maiden name. She remained as landlady until the pub was sold to Ind Coope's brewery in the early 1920s. Moulton housed mainly salt workers from the many Winsford salt works a short way off via the railway arches. The village is ancient having been mentioned in the Domesday Book but grew quickly in the 1800s to serve the salt industry. A very insular community then with a tremendous spirit, a cottage was built at the end of School Lane in 1871 with a clock on the wall to serve villagers who could not afford their own timepiece. Initially it housed a cobbler/clog maker.

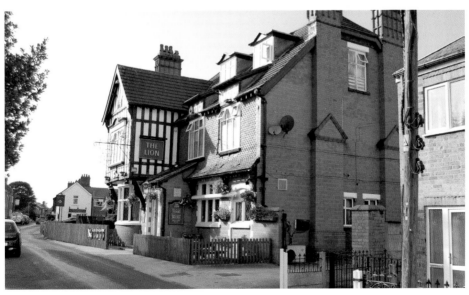

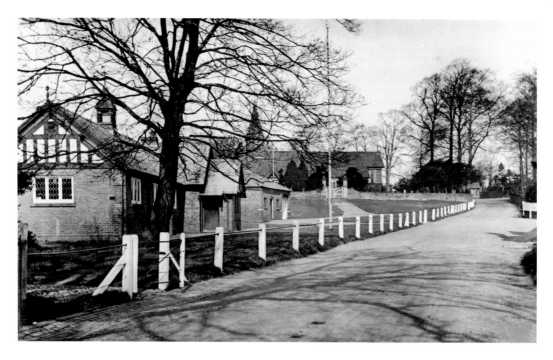

Whitegate Village *c.* 1950s & 2009

In this pleasant village betwixt Winsford and Northwich we look up the main street towards the church of St Mary. This parish can be traced back to the building of the nearby Vale Royal Abbey. The abbey was named by King Edward 1 'Vallis Regalis' (Vale Royal), hence the name. The monks moved to the Abbey in 1330 and it was completed by 1359. On the dissolution St Mary's became Whitegate Parish Church. The present building dates from the nineteenth century and was designed by John Douglas of Sandiway.

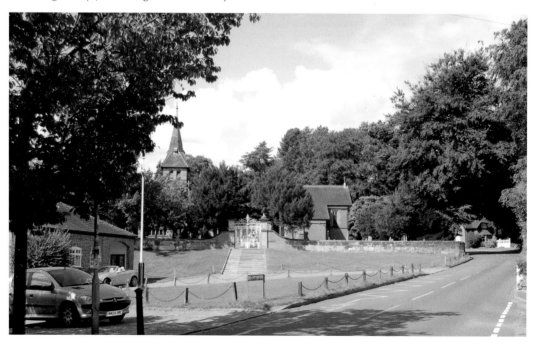

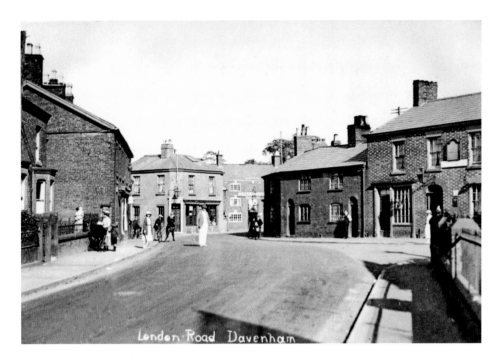

London Road Davenham

London Road Davenham *c.* 1910 & 2009

This view taken from the Davenham roundabout side looks towards the Bulls Head in the distance and the Oddfellows on the right. The cottages after the Oddfellows have been demolished but the view is remarkably unchanged. The Bulls Head has existed since 1764 and the Oddfellows since 1851. Once a very busy road, this has now been calmed by the long fought for Davenham bypass. Paula Radcliffe MBE was born in Davenham.

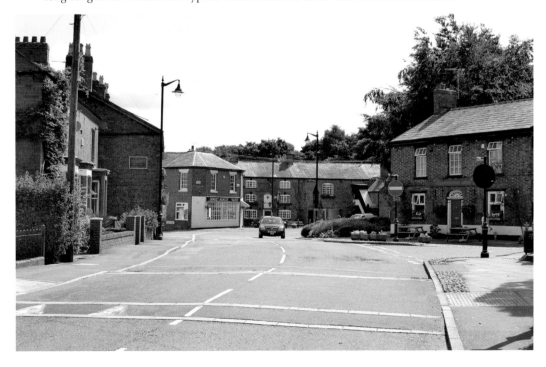

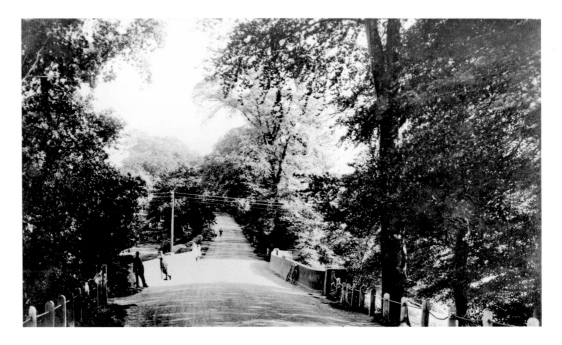

Hartford Bridge c. 1900 & 2009

Here we see how things have changed. From a pretty stone bridge accommodating little traffic, the steel bridge opened in 1939 as Hartford Bridge. It carried the Northwich bypass and due to the paint colour it became known as The Blue Bridge, the narrow stone bridge had existed there for many years. Northwich bypass or the A556 was built during the 1930s and 1950s; this was a period of building in a similar manner to that undertaken in Germany when work was provided for the many unemployed by building autobahns that ran straight and true through Germany. This impressive road, which included a cycle track, ran from Manchester to Chester and is now dual carriageway for a lot of the way.

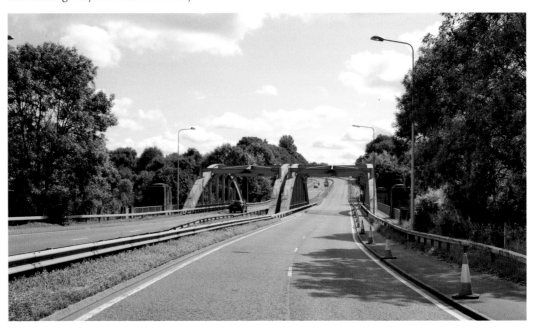

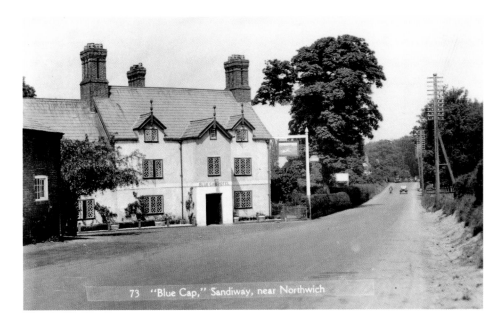

73 "Blue Cap," Sandiway, near Northwich

The Blue Cap c. 1920s & 2009

The ancient road from Chester to Manchester once carried the mail coaches that travelled between the two cities and onwards. Hotels were used as staging posts for this traffic and an important one was the Sandiway Head Inn. This famous old inn, which stood on the foundations of an even earlier one, was later to have its name changed to the Blue Cap. The name comes from a foxhound called Blue Cap whose owner was challenged to race him in 1762. The challenge was accepted and in the subsequent race at Newmarket, with a purse of 500 guineas, Blue Cap came first and his daughter, Wanton, came second, winning 400 guineas and 100 guineas respectively. After that the dog was a legend. Now a popular gastro pub, there is a large statue of a dog in the entrance hall.

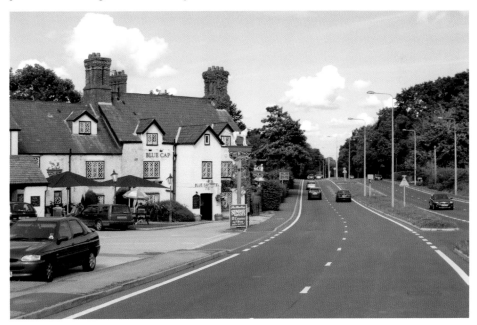

Oakmere Police Station, 1970s & 2012

Not such a gap between then and now here but I believe that this building deserves a place in the book. It was built as a police station and court house to take over from the nearby Vale Royal Abbey Arms pub. Prior to its building in the nineteenth century, the court was held in the pub and felons detained in the cellar. It went on to be the divisional headquarters for Eddisbury Police Division and stables were built at the rear for the superintendent's horse and trap. Its last duties were as Oakmere Magistrates' Court and despite an appeal to save it; it has been empty and deteriorating since the 1980s. I believe that re-development plans are currently afoot.

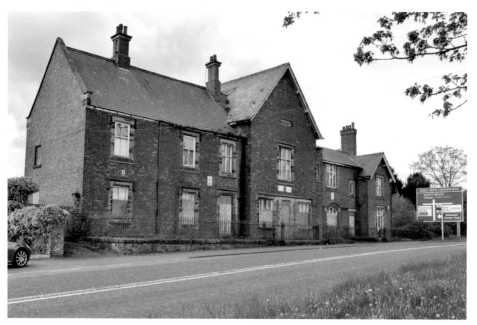

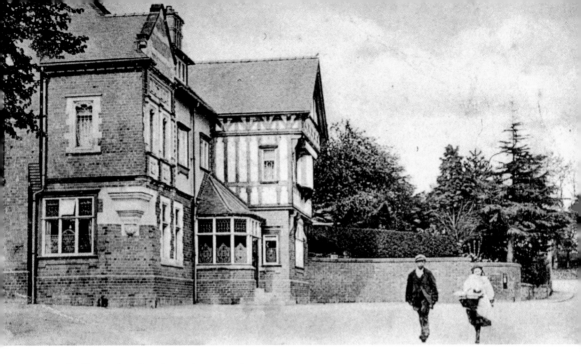

Kelsall Royal Oak Pub, Early 1900s & 2012

Kelsall was once a military post of some importance. It is situated on the now by-passed road from Manchester to Chester and is on the edge of Delamere forest. The original Royal Oak was built in 1822 and was a public house and inn through the 1800s. In 1880 the pub was owned by Joseph Roberts of the firm Roberts & Son who were entrepreneurs in the town involved in the manufacture of steam-driven equipment, they were also insurance agents. In 1900 the pub was demolished and re-built. By 1910 the landlord was Samuel Roberts. Having been closed for a time, it has now been re-opened as a first-class gastro pub called the Oak.

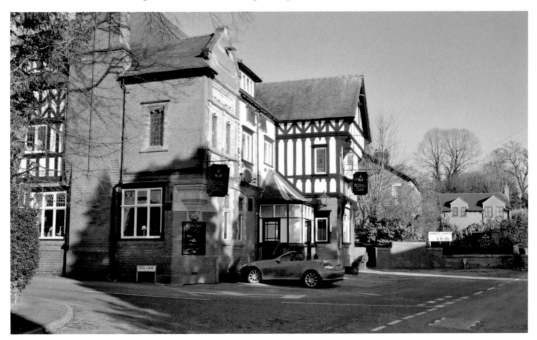

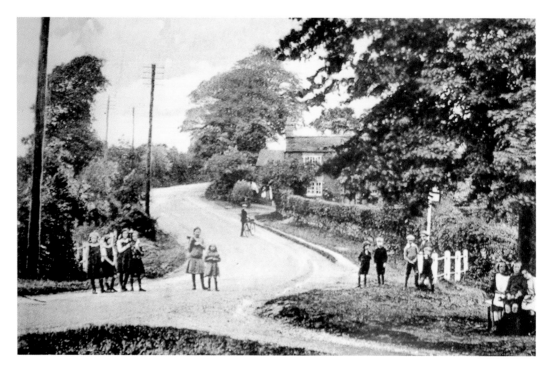

Cotebrook, 1895 & 2009

Now on what is the A49 Tarporley Road and the road through the hamlet of Cotebrook. Little has changed over the years other than the vast increase in traffic. Those children would not have been able to stand where they are. In fact taking the new photograph meant risking my life on this fast and busy arterial road! A huge articulated lorry is just coming into view in the 2009 photograph.

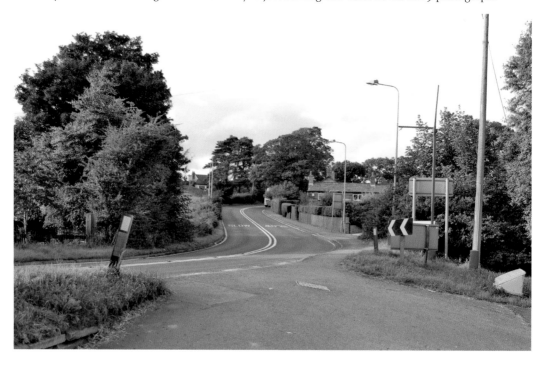

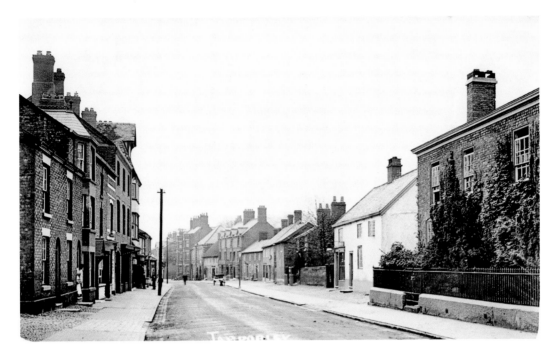

Tarporley, 1900 & 2012

Tarporley, once called Torporley is a rather well-to-do large village that despite being by-passed with a new road still attracts heavy traffic as can be seen in the new photograph. In 1900 it was a different matter with pedestrians strolling leisurely down the street and one barrow taking the place of the many cars. The white cottage on the right has been demolished and the bank has lost its coating of ivy.

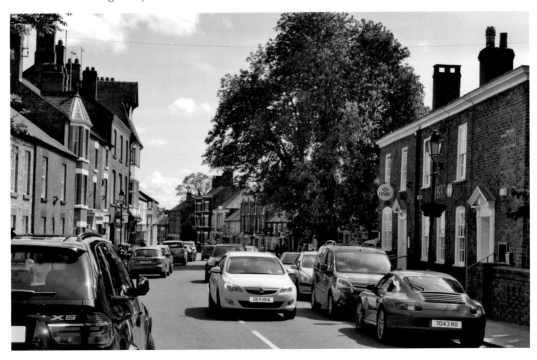

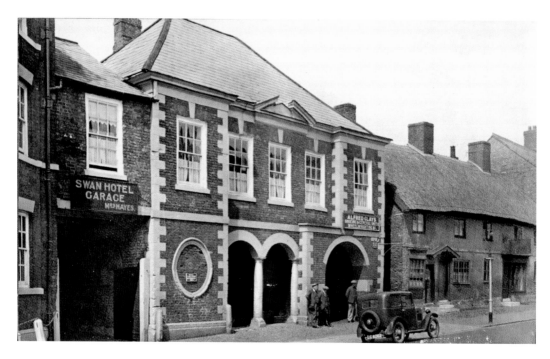

Tarporley c. 1930 & 2012

Now we travel further down the main street to what is the ancient Swan Hotel, in the old photograph we see the arch through to what was the garage to the hotel, now the car park. That is the only part of the hotel that we can see, the main building in the photograph dates from around 1758 and was the market hall, the market was originally held on the ground floor which was open. The materials for building it came from Utkinton Hall and the Cheshire Hunt have almost always used this building for meetings. The building is linked to the next door Swan Hotel.

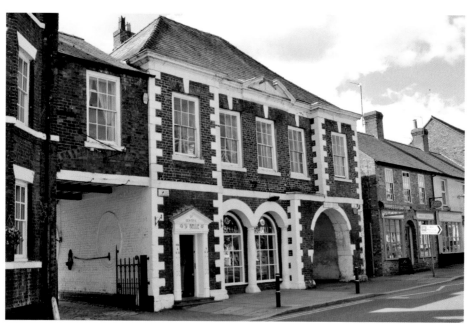

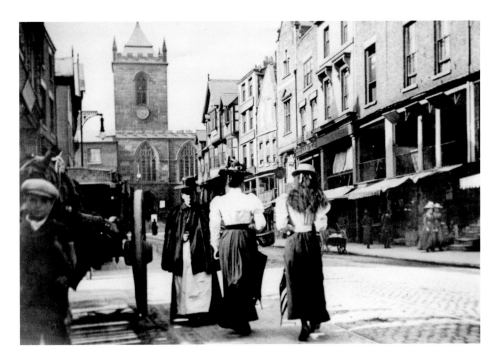

Chester Bridge Street *c.* 1900 & 2010

Now we come to one of the finest cities in Great Britain, a city that oozes charm and historical ambience. Chester with its Rows, museums and many features tempt the visitor. This photograph is of the ancient Bridge Street that takes the pedestrian from the River Dee to the city. In this photograph we see a view up Bridge Street towards St Peter's church at the Cross as we see the ladies in their Victorian fashions walking past a heavy horse-drawn cart. Little has changed as far as the buildings are concerned and the road surface still consists of stone sets although whether they are original is another matter, note the tram lines!

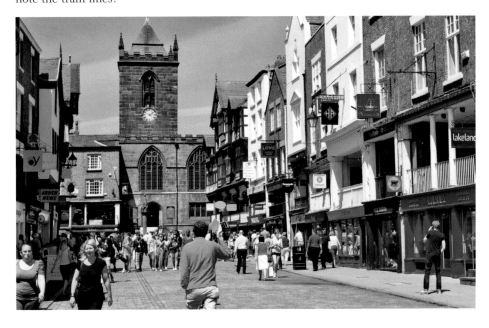

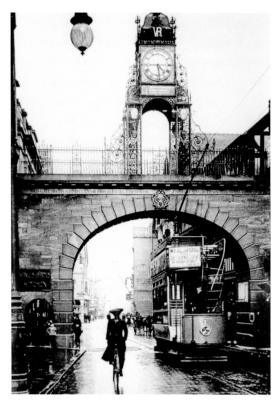

Chester The Clock, 1910 & 2010
A look at the famous clock which straddles the City Walls over Eastgate Street now with a photograph taken of Eastgate Street away from the cross, the clock was designed by the Sandiway architect John Douglas to celebrate Queen Victoria's Diamond Jubilee. It was built by the cousin of John Douglas, James Swindley of Handbridge and the clock itself provided by J. B. Joyce of Whitchurch. Until 1974 it had to be wound by hand every week and is said to be the most photographed clock in the world after Big Ben. Note the lady bicyclist and the horse trams have been replaced.

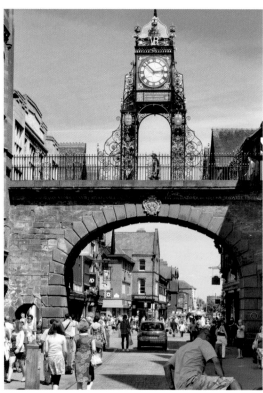

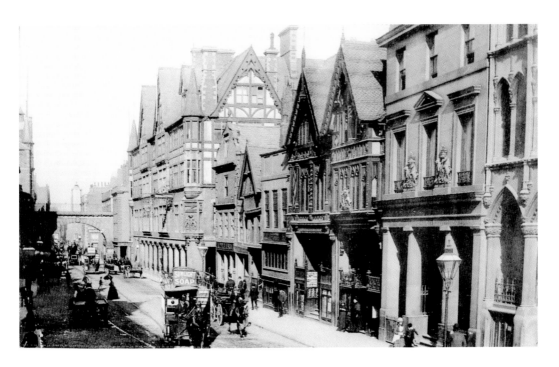

Chester Eastgate Street Towards The Clock, 1897 & 2010

Here we have quite a unique photograph as it shows the famous Chester Clock which straddles the City Walls over Eastgate Street. This old photograph was taken as the clock was under construction and was to celebrate Queen Victoria's Diamond Jubilee in that year. This photograph is absolutely filled with period charm with horse trams and many other forms of horse drawn transport. There have been some alterations to the buildings, but in the main little has changed architecturally.

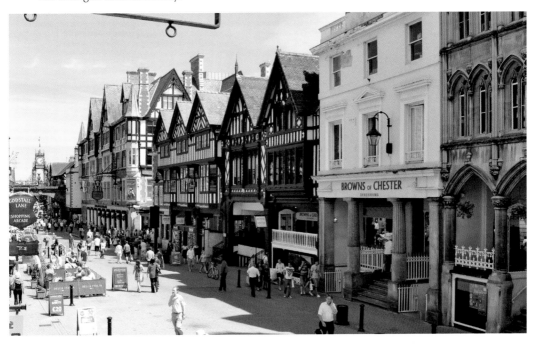

Chester The Cross, 1860 & 2010

This ancient photograph depicts one of the rarest views of what is known as the Chester Cross area and shows a building in a very poor state. By 1888 it had gone and in its place was built the beautiful black and white building shown below. That can be seen in the new photograph, we see that some of the buildings further down Bridge Street are still standing. What photograph of Chester is more iconic than of this 1888 building that stands on the corner of Bridge Street? It was designed by Thomas Lockwood.

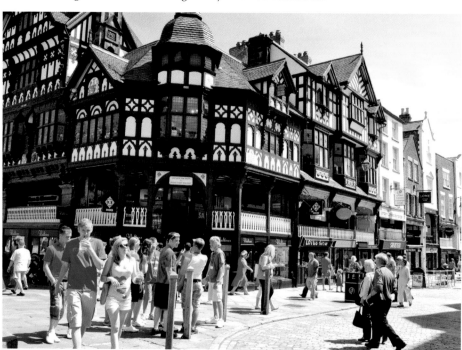

Chester Eastgate Street *c.* 1955 & 2010
These photographs were taken from the walls near to the Eastgate Clock as we look down into Eastgate Street towards the Cross. A policeman can be seen on point duty at the junction with St Werburgh Street. It looks rather a thankless task with a myriad of pedestrians and motor traffic seemingly wandering about at will! One of the attractions that Chester offers the visitor is antiquity and this photograph shows just how little has changed over the years.

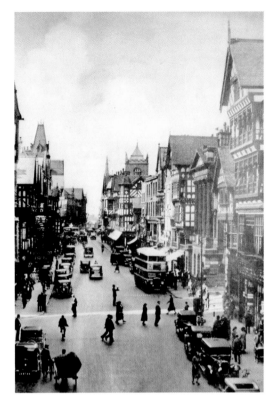

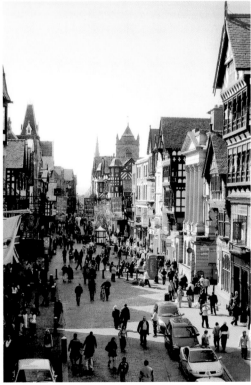

Chester, Site of Old Tobacco Works, 1948 & 2010

The old photograph here shows the very attractive Nichols Tobacco and Snuff Mills in 1948, many local people were employed here making all forms of tobacco products. The firm was established in 1780, it was closed and was unoccupied when there was a fire here in June 1950 and it was demolished. At a later date, in an era not renowned for architectural excellence, planning permission was granted for the building of the extremely un-attractive Salmon's Leap blocks of flats as seen in the modern photograph. What would the brilliant architects John Douglas or Thomas Lockwood have thought of them?

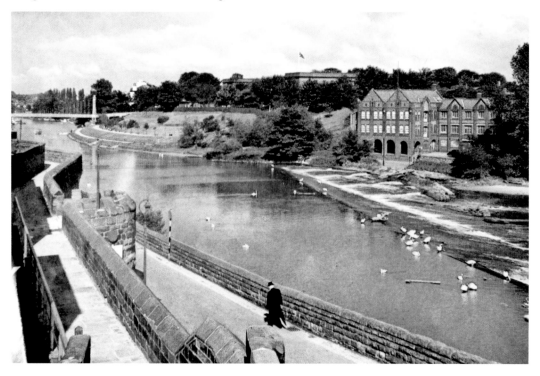

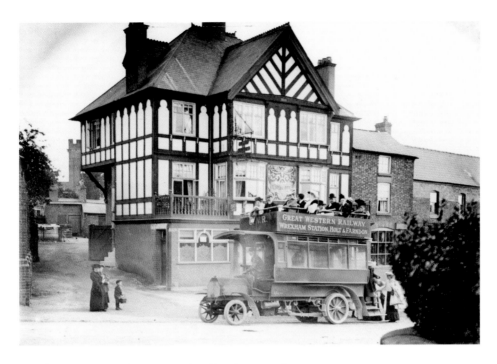

Farndon Raven Hotel Now Farndon Hotel *c.* 1915 & 2012

Farndon is a village on the banks of the River Dee. It is 8 miles south of Chester and close to the Welsh border. Farndon is linked to the Welsh village of Holt on the other side of the River Dee and the river is crossed by a famous medieval bridge dating from 1339. In the old photograph we see an omnibus outside the sixteenth century Farndon Hotel, once known as the Raven.

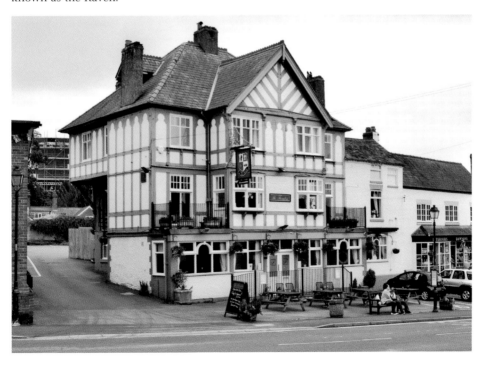

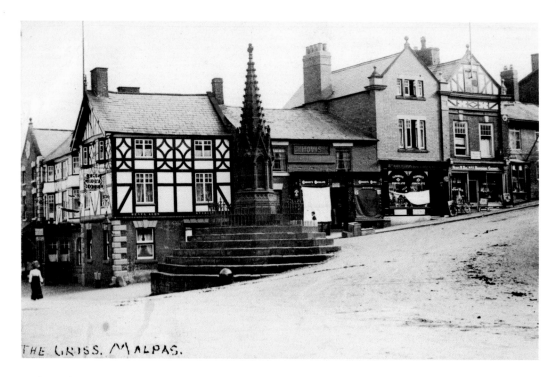

THE CROSS. MALPAS.

Malpas The Cross *c.* 1910 & 2012

Malpas is a large village that lies on the border with Shropshire and Wales and the name is from Old French. The photograph shows the Malpas Cross, which has a medieval base. The upper section however was erected in 1873 to commemorate Reverend Augustus Thurlow M.A. the local vicar at the time. It stands at the junction of Church Street, High Street, Well Street, and Oldhall Street.

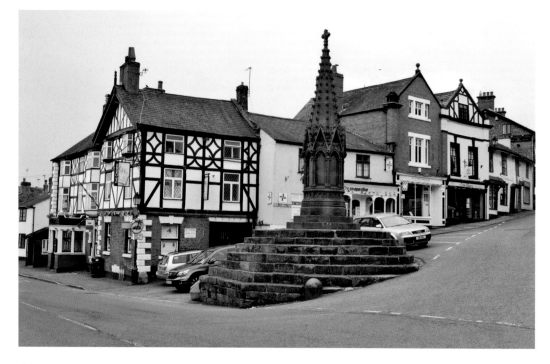

Great Budworth, Undated & 2009

We now visit Great Budworth and we see just how little has changed over the years and why the village is such a favourite with period film-makers. The old photograph is undated but with the right turn sign I would guess that it is the mid 1900s. This is Church Street looking towards St Mary and All Saints church. The oldest part of the church is the Lady Chapel which dates back to the fourteenth century. The rest of the church can be dated to the fifteenth and sixteenth centuries.

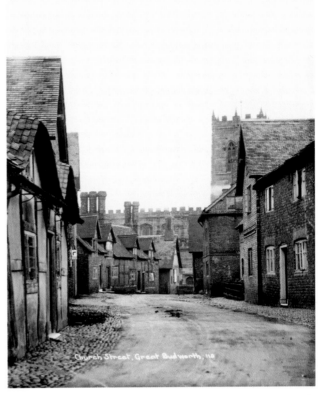

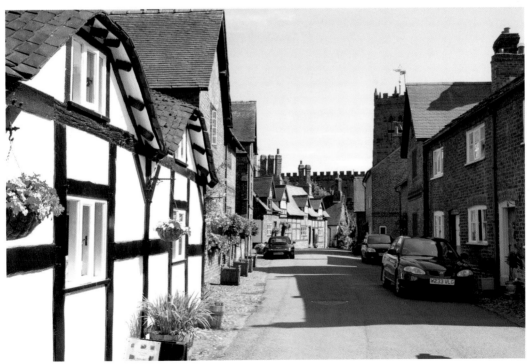

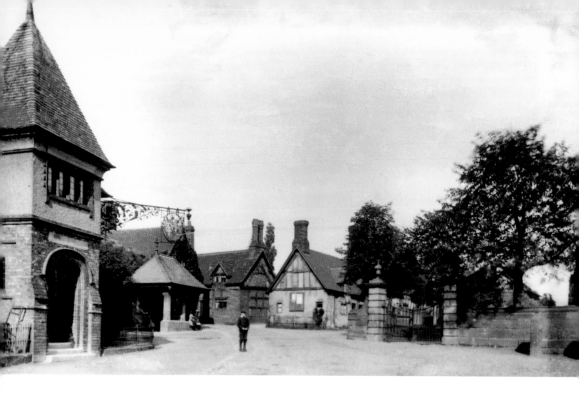

Great Budworth Stocks, 1905 & 2009

Most ancient villages had a set of stocks, usually as in this case near to the church. They were used up to 1854 to calm the village scallywags and deter those from other villages. To sit strapped into them for a while as rotten fruit is thrown at you is a deterrent that perhaps may work now! The photographs show the village centre with the lychgate to the church and the George & Dragon pub. After the forced closing of the lesser public houses in the village many years ago the George & Dragon is the only one remaining. It is now under new management and has been refurbished back into a typical village pub.

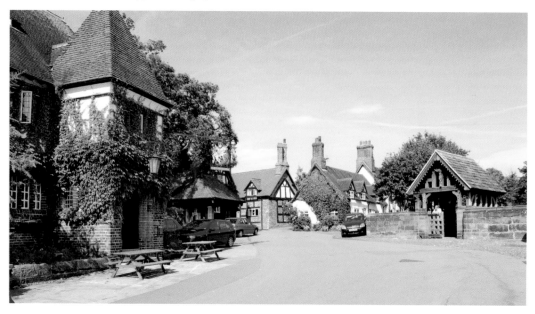

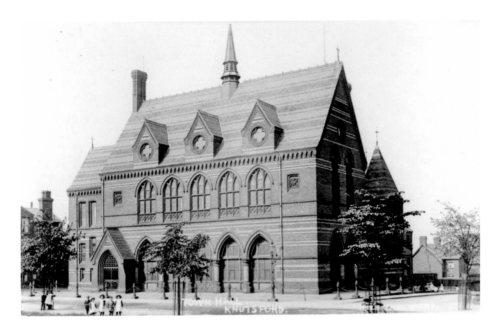

Knutsford Town Hall c. 1900 & 2011

This beautiful building was built in 1872 by Lord Egerton of Tatton and designed by Alfred Waterhouse who was also responsible for, amongst other buildings, Manchester Town Hall and the Natural History Museum in Kensington. Originally it had a market hall on the ground floor and at this time the archways were open in typical market architecture. An important incident occurred here in the war years. General George Patton then based at Peover Hall was invited to open it as a Welcome Club for soldiers. He was not due to make a speech but was invited to, and made an off-the-cuff speech being mis-quoted around the world. It was said that he snubbed the Russians. This was known as the 'Knutsford Incident' and in the short term damaged his career.

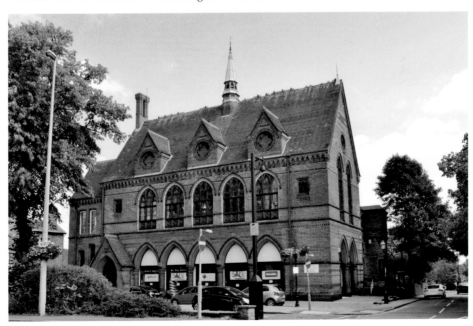

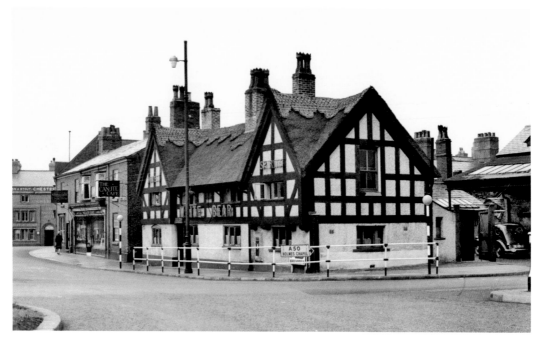

Knutsford White Bear Pub, 20 May 1950 & 2011

A look now at the ancient White Bear, this pub was extensively altered on the front elevation in the late 1800s when it gained the attractive black and white paint. In 1880 the address of the pub was Heath Side and Mrs Elizabeth Edwards was the licensee and farmer. During the 1940s/1950s the attractive thatched roof caught fire. Fortunately the option of replacing the roof with cheaper tiles was not taken and what we have is a beautiful black and white thatched building to welcome visitors to Knutsford.

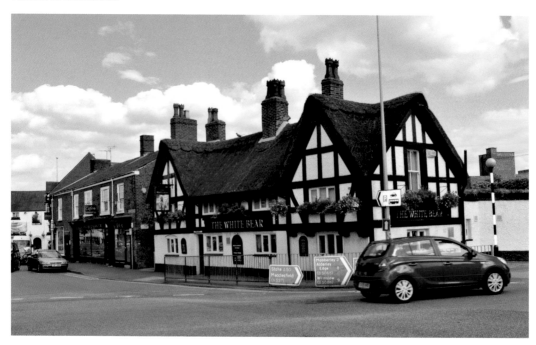

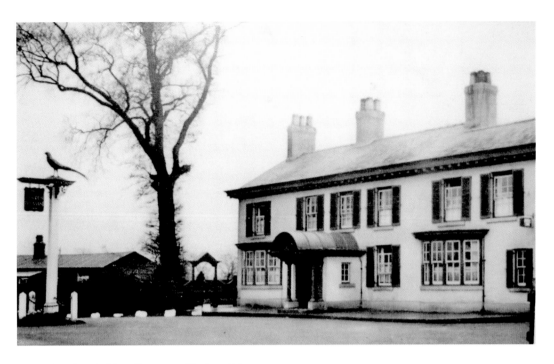

Plumley Golden Pheasant, Undated & 2012

The Golden Pheasant is a hotel in Plumley Moor Road, Plumley. In 1900 it was known as the Railway Inn and Michael Power was the licensee. At this time the village was known as Plumbley. By 1934 it had been re-named and Mrs Edith Wood was the licensee. This attractive and comfortable hotel is believed to be around 200 years old and although the old photograph is undated it is likely to have been taken around the mid 1900s. Over the road is Plumley railway station on the Chester/Manchester line. With trains running regularly, this makes the hotel an excellent base for touring Cheshire and the cities.

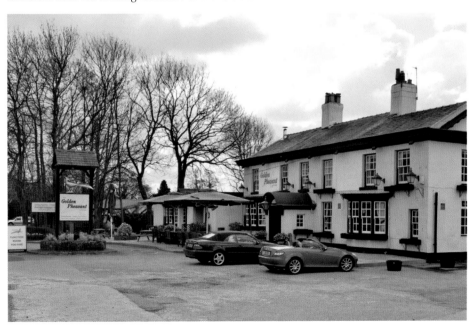

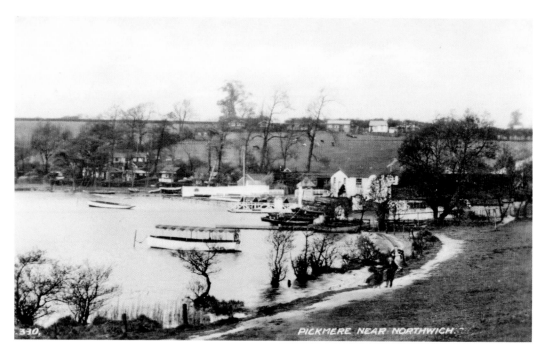

Pickmere Lake, Early 1900s & 2009
Pickmere Lake in Pickmere near Northwich was for many years a holiday destination. In this early 1900s photograph boats are for hire and cruises on the lake by steam boat may be enjoyed. As time passed this entertainment included a permanent fairground that as children we would enjoy. It is now simply a pretty lake with pleasant walks around its perimeter. There are also strategically placed picnic areas.

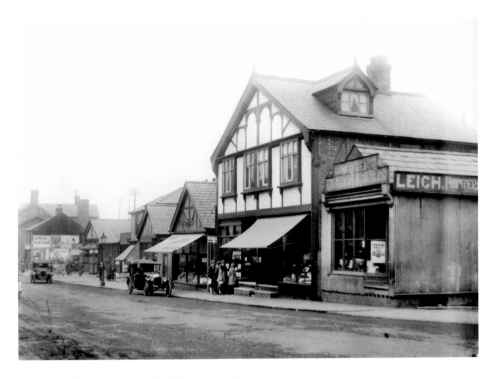

Northwich Lower Castle Hill *c.* 1920s & 2009

We enter Northwich now and the longevity of the building in the picture can be put down to its ability to be jacked up, thereby making good the effects of subsidence. In the older photograph taken in the early 1920s the firm of George & William Leigh, painters can be seen. Amazingly this small apparently flimsy building is still fit and well almost ninety years later where a hairdresser is in residence.

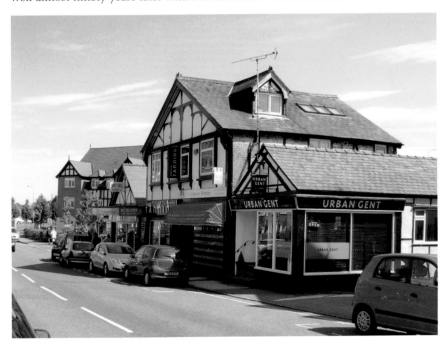

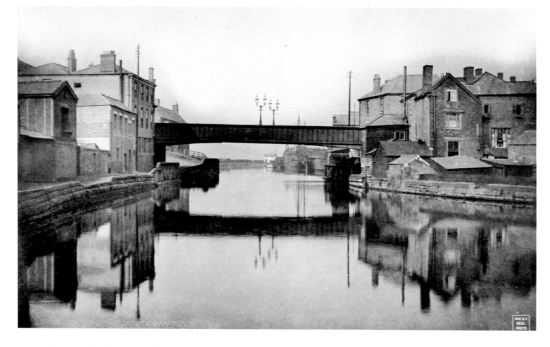

Northwich Town Bridge pre-1899 & 2009

The bridge shown in the old photograph replaced an older stone one in 1858. By the end of the century subsidence had arrived with a vengeance and the bridge was sinking. It was decided to build another using a new method whereby the bridge would sit upon a floating pontoon in the river. The result is the one shown in the 2009 photograph. The bridge was the second of its type, the first being Hayhurst Bridge in Chester Way, which was built in 1898. The Town Bridge was built in 1899 and both were designed by Colonel John Saner. The bridges were the first two electrically-powered swing bridges in Great Britain.

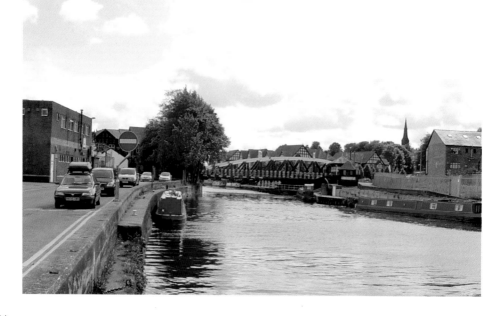

Northwich Post Office, 1930 & 2009
As we linger in another major depression it's timely to see a photograph of the Great Depression which lasted from 1929 onwards to the war! This photograph has been marked as soldiers guarding people at the Labour exchange. I think it more likely that they are amongst those queuing as they are standing around in uniform, some smoking. The Labour Exchange is next to the post office. The Post Office building, although looking ancient, was built in 1914 with the ability to be jacked up in the event of subsidence. It is now a Wetherspoon's Pub called the Penny Black.

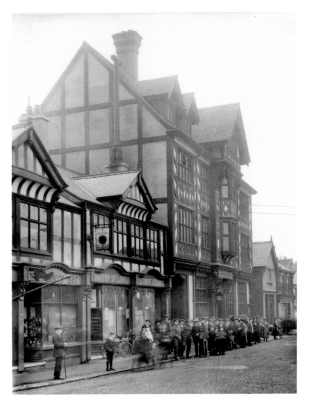

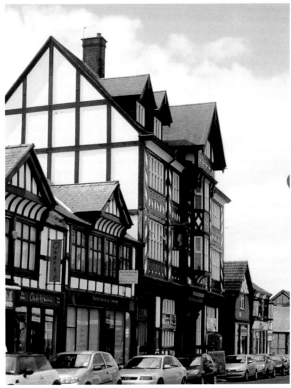

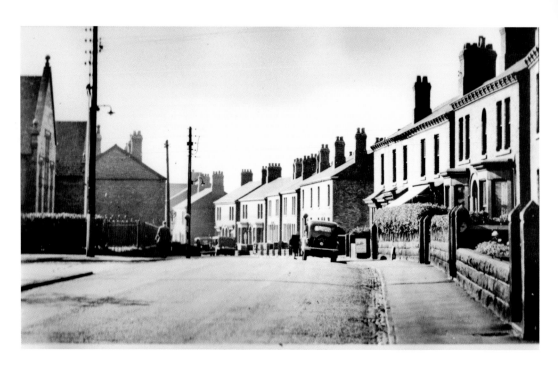

Barnton Lydyett Lane, 1950s & 2009
One of the main roads in Barnton that leads down to Gunnersclough, we look back towards the Townfield Lane junction. The large building on the left in the old photograph has been replaced by a Co-op store in the new. This building was the Brunner School built in 1895. In 1964 it was converted into a Village Hall and in 2005 demolished when the new Memorial Hall was opened in Townfield Lane.

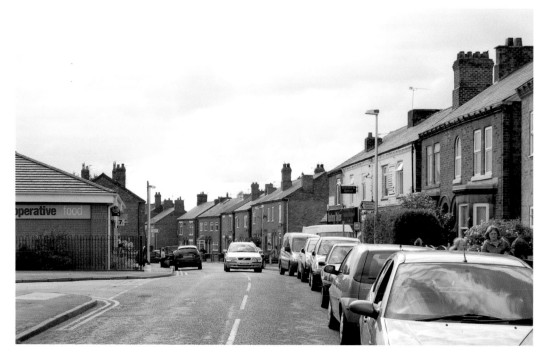

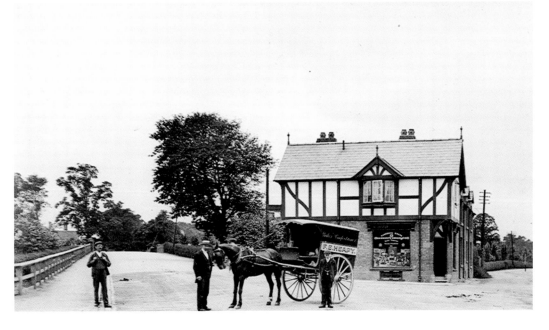

Greenbank Junction, 1898 & 2009

These photographs show the junction with Chester Road and the strangely named Beach Road. Little has changed, but the shop in the centre has had several uses over the years. It's lucky that it's still there as this junction was very precarious in the days of pea souper smogs. I well remember the flickering oil lamps that used to be put where the island is. To the left of the important man holding his lapels is the station, originally called Hartford and Greenbank. The name was changed to simply Greenbank to avoid confusion with the nearby Hartford Station on the West Coast Main Line. The station buildings have now been converted into a church. The pony and van belonged to Frederick Edmund Heapy, a grocer of 13 Waterloo Street Castle, Northwich.

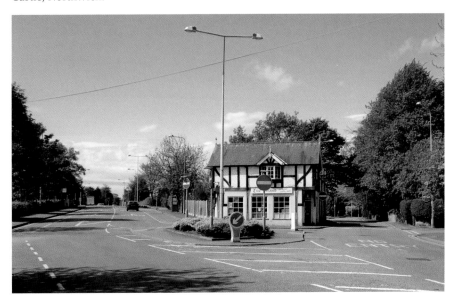

Weaverham High Street, 1900 & 2009

In this the first of the photographs of Weaverham High Street we look into the old village from the Northwich direction and people walk around in the roadway. In the 2009 photograph the row of cottages on the right has gone leaving open land to the Wheatsheaf pub. Other than this, there is little in the way of change over the intervening hundred plus years. The old Wheatsheaf pub dates back to 1822 and probably further back to the 1700s. It was very popular through the years in which the village elders ruminated over glasses of ale in the Knowledge Room, a bar room at the front of the building.

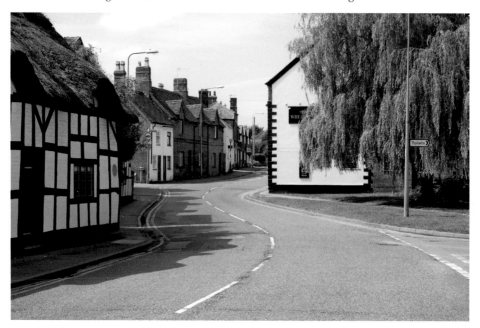

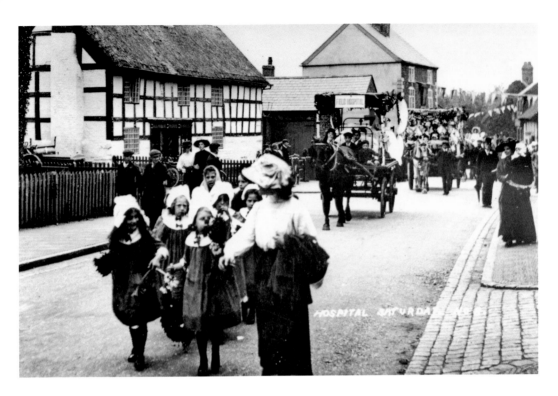

Weaverham Hospital Saturday *c.* 1915 & 2009

The old black and white building housed William Phipps, painter and plumber. The procession is in aid of Northwich Infirmary and is titled Hospital Saturday. This dates the photograph to before 1927 when it became known as the Weaverham Rose Festival, later Rose Fête. What a pretty picture the modern one is with the gleaming white paint and exposed beams. The float with the name Field Hospital on the front would suggest a period during the Great War.

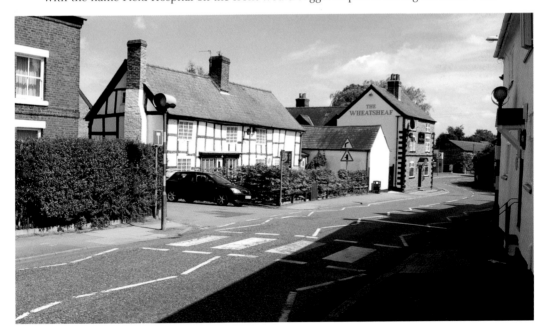

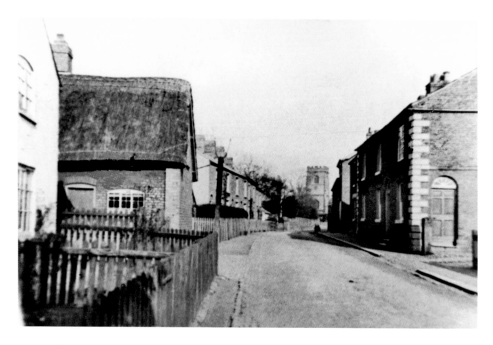

Weaverham Church Street, Undated & 2009

The parish church of St Mary the Virgin is situated at the end of Church Street and dates to the fifteenth and sixteenth centuries. Raintub Cottage which can be seen on the left dates from around the time of Henry VIII. When under renovation in the 1980s a wall painting was discovered on the wattle and daub wall beneath layers of plaster. It depicted the branches of a yew tree, which was painted for both decoration and to fend off evil spirits as the yew was indigestible and sometimes fatal if eaten, so was effective against demons. There is a coffin hole in the half loft ceiling as a coffin would be too large to bring down the narrow staircase. Note the now demolished terraced cottages on the right; these cottages have been replaced with modern houses.

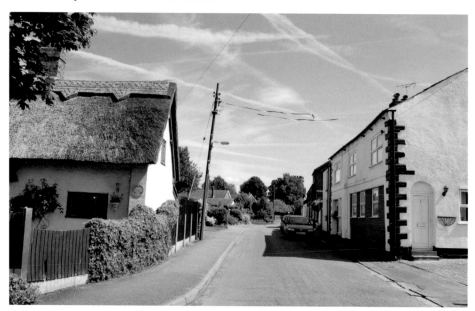

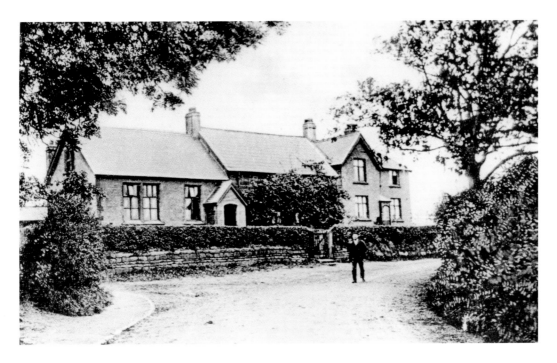

Weaverham Grammar School, 1905 & 2009

Just off the roundabout on the bypass in Forest Street is the old grammar school building, now a dwelling house. It is believed to date from 1638 and was once a courthouse. It was damaged in the Civil War and was a grammar school for hundreds of years catering for the children of farmers in the area. It closed as a school in 1916, the last headmaster being John Trickett. A bit further on is a house that was once Weaverham police station.

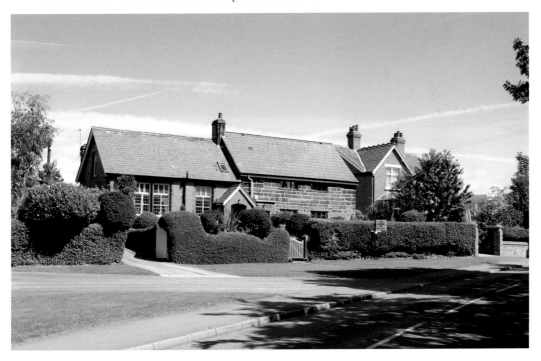

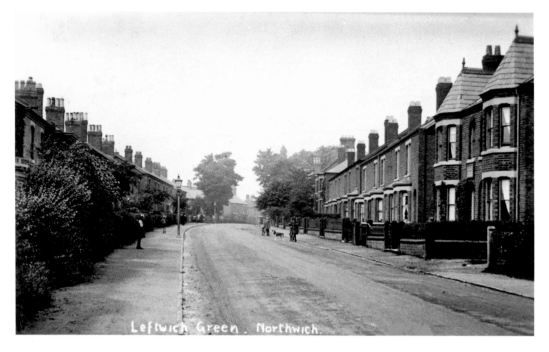

Leftwich Green, 1895 & 2009

This village, situated between Northwich and Davenham, was many years ago held by the Wilbraham family. An heiress of the family married Robert de Winnington whose son Richard assumed the local name and was the founder of the family of Leftwich. Little has changed in the intervening hundred plus years. The two bay-windowed houses are in the foreground. Leftwich Green was expanded greatly after the war with the building of a large council estate.

Frodsham Main Street *c.* 1915 & 2009

At the junction with Church Street Frodsham, we look towards High Street and onwards towards Runcorn. The vista is the same albeit that the modern photograph was taken from slightly further back. The dray and lorry in the old photograph was once a common sight and, with such quiet roads, the driver felt comfortable making his way down the centre of the road.

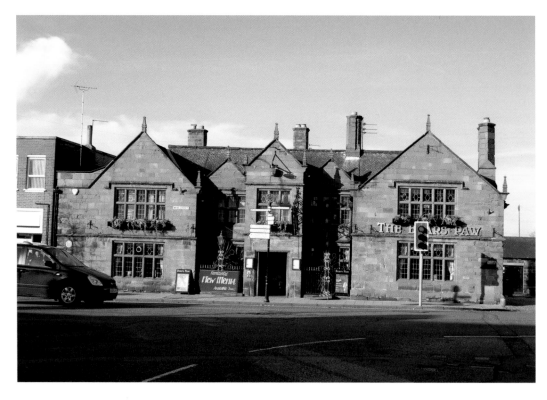

Frodsham The Bear's Paw *c.* 1880s & 2009

This ancient hostelry with a headstone above the door giving its year of construction as 1632 can trace its landlords back to John Smith in 1784. The post office was once inside the inn and during the 1800s went by the names of The Bear's Paw & Station and then The Bear's Paw & Railway. The old photograph here is from the early days of photography.

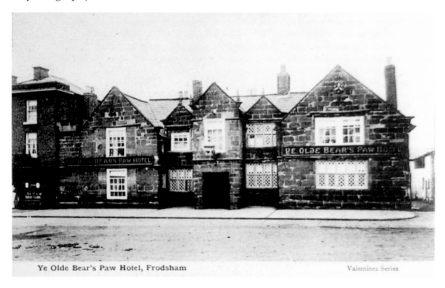

Ye Olde Bear's Paw Hotel, Frodsham Valentines Series

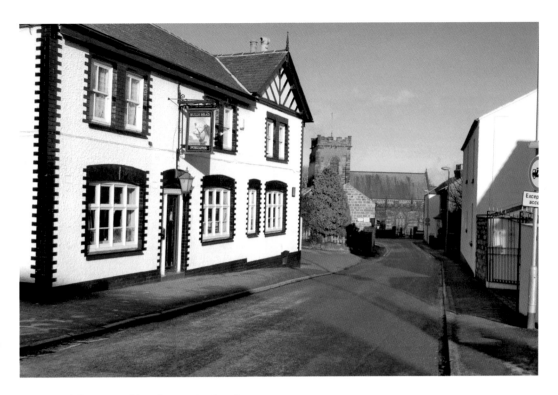

Frodsham Ye Old Bulls Head, 1850 & 2009

Not the best quality of old photograph but deserving of inclusion due to its age. This ancient photograph is of the old Bulls Head Pub at Overton. As can be seen it is a different building to the modern one although there has been a Bulls Head there throughout. The licensee at the time of the old photograph was Thomas Wright and the church has yet to be modernised in 1880.

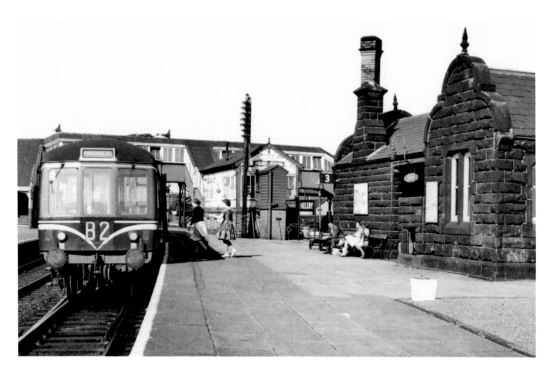

Helsby Station, 1950s & 2009

We now travel to Helsby and stop at the railway station, in the old shot is a 'cat's whiskers' diesel railcar on the way to Birkenhead. This pretty sandstone station is a junction with lines coming in from the Wirral, Chester and at one time Mouldsworth.

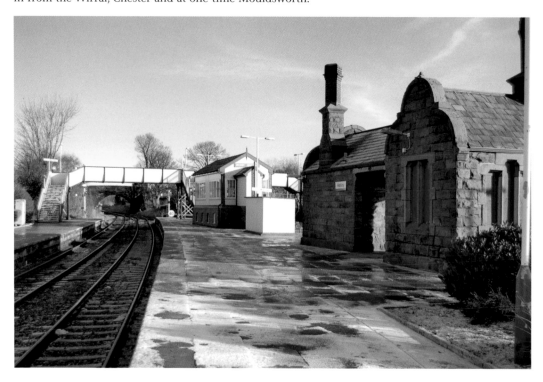

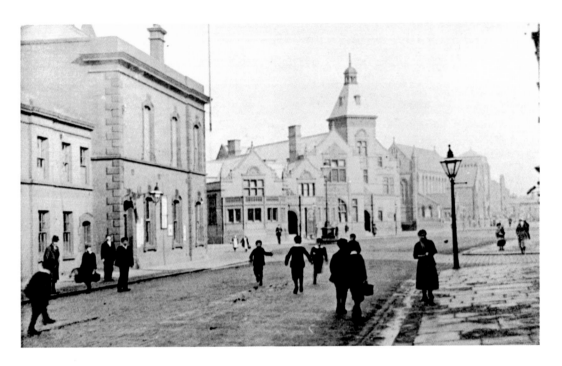

Widnes Victoria Square *c.* 1900 & 2012

The Vikings are believed to be the first to settle in the Widnes area in any number. The town was named Vidnes meaning a wide nose or tree covered promontory. Prior to the transporter (see next page) a ferry travelled between Runcorn and Widnes. Without this, crossing the Mersey was a long and convoluted journey. Until 1974 Widnes was in Lancashire and the river made a natural county border. The buildings on the left in the old photograph were demolished for road widening leaving a better view of the beautiful red brick buildings including the Kingsway Learning Centre and the parish church of St Paul's.

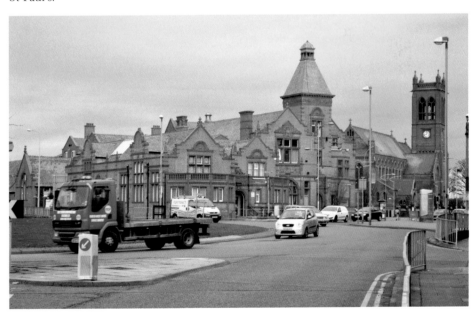

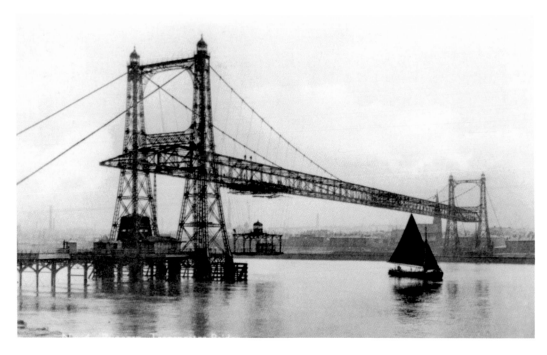

Runcorn Transporter c. 1930s & 2012

Prior to 1905, the only means of crossing from Runcorn to Widnes was by train or ferry. In 1899 the Widnes & Runcorn Bridge Company was established under the chairmanship of Sir John Brunner and their decision was to build a transporter bridge. This would be cheaper than an orthodox type of bridge and the passage of the transporter car could be timed to allow the passage of the ships. It was opened and operated from 1905 to 1961 when the new Runcorn Bridge was built at which time it was demolished. At the time of writing, that bridge is being widened. See the transporter car in the inset.

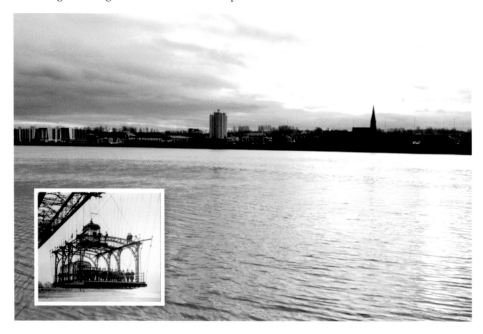

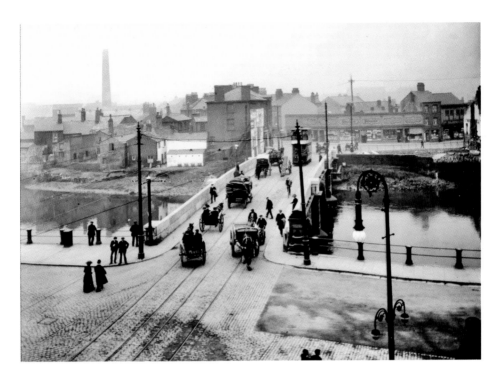

Warrington Bridge Foot *c.* 1900 & 2012

Warrington was once in the County of Lancashire but was brought into Cheshire at the 1974 amalgamation. The bridge in the old photograph crosses the Mersey and is dated around 1900, the area is known as Bridge Foot. It was built in the year of Victoria's Coronation in 1837 and was accordingly named Victoria Bridge. By the turn of the century it was decided that it was no longer big enough to cope with the increased traffic and in 1913 King George V unveiled the first section of the present bridge.

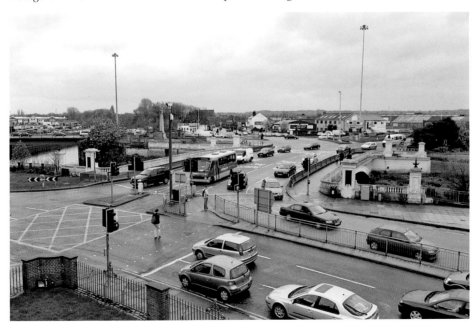

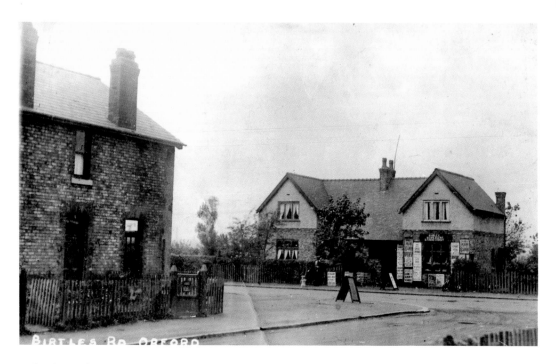

Orford Warrington, 1920 & 2012

What can I say of this shop other than it has my name above the door? Well at least the old one does as it was owned by my grandparents when the photograph was taken around 1920. The business was Hurley, Newsagent and Tobacconist and the picture comes from a postcard sent to my uncle Joe who was serving on HMS *Renown*. Sadly he was on HMS *Exmouth* when it was sunk with all hands in 1939. As for the building, it is still a shop and over the years it has been extended at the rear.

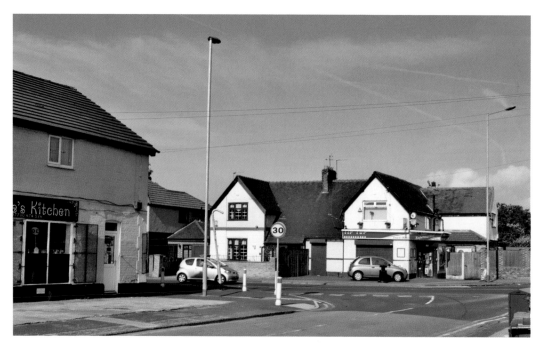

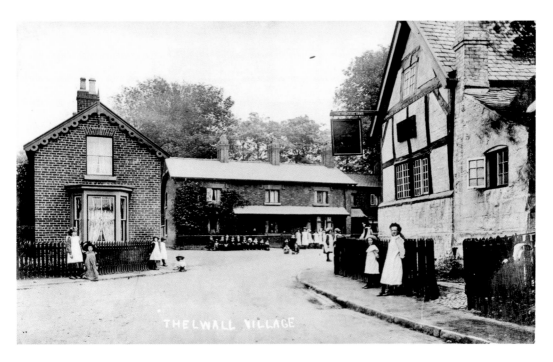

THELWALL VILLAGE

Thelwall c. 1900 & 2012

Thelwall is a small village and a suburb of Warrington. It is now better known for the Thelwall Viaduct that carries the M6 over the Manchester Ship Canal. The pub in the photograph is the Pickering Arms and it has an inscription on the wall that records the words 'In the year 920 King Edward the Elder founded a city here and called it Thelwall.' So I suppose that makes Thelwall the smallest city in England. City or village it is certainly beautiful and the old photograph is filled with period charm.

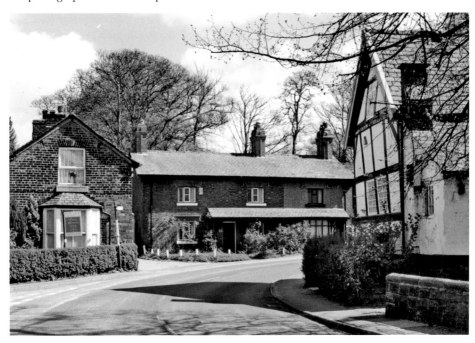

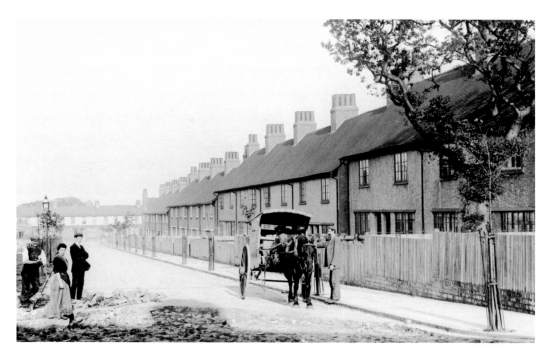

Ellesmere Port Housing Estate *c.* 1920 & 2012
It is nice to feature ordinary streets through the years and here is an excellent example. Taken around 1920 Dudley Road in Ellesmere Port is a new estate, judged by the houses and the ornamental trees planted on the footpaths. A workman can be seen watching the cameraman on the opposite side of the road, the surface of which is yet to be laid. The baker's boy with his pony and van are on hand to deliver bread from their Dock Street bakery.

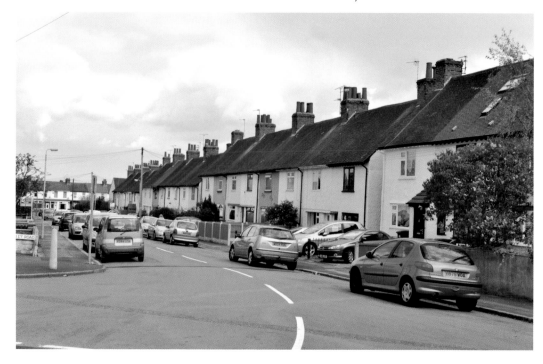

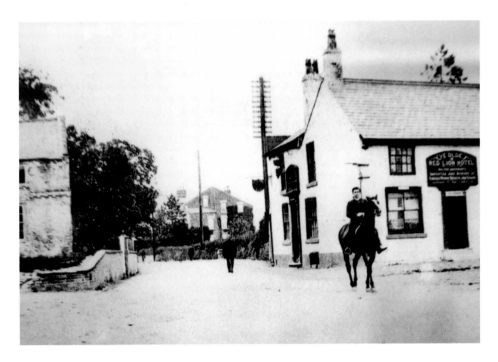

Little Sutton Red Lion *c.* 1900 & 2012

Here is an interesting and ancient pub called Ye Old Red Lion in the old photograph dated around 1900. By 1934 the Chester road needed widening so the old pub was knocked down and a new one built and set back further to make way for the wider road. It is the new Old Red Lion that can be seen in the new photograph. A gentleman who once lived and allegedly misbehaved here was the man with the reputation as the most violent prisoner in Britain, Charles Bronson.

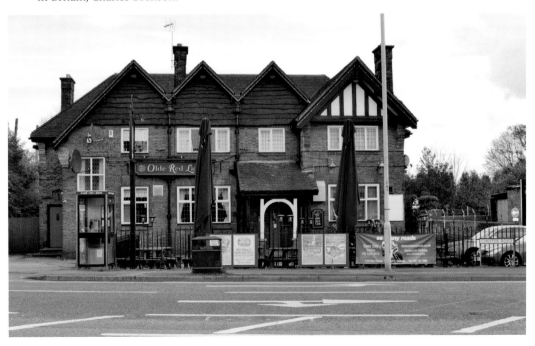

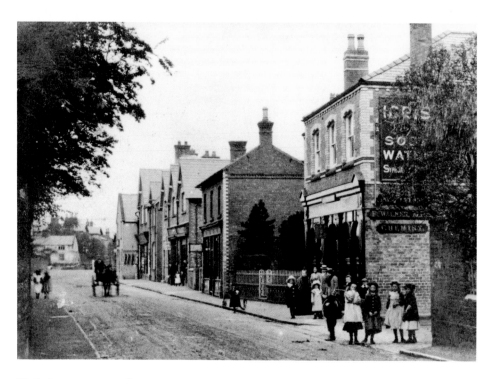

Little Sutton *c.* 1900 & 2012

Little Sutton is on the Birkenhead to Chester Road, a suburb of Ellesmere Port. As can be seen with the two photographs, not much has changed here over the years. In fact the large building with the advert for Idris drinks on the gable end was a chemist and post office in 1900, when Frank Walker had the business. Come forward 112 years and it is still a chemist called Sutton Pharmacy.

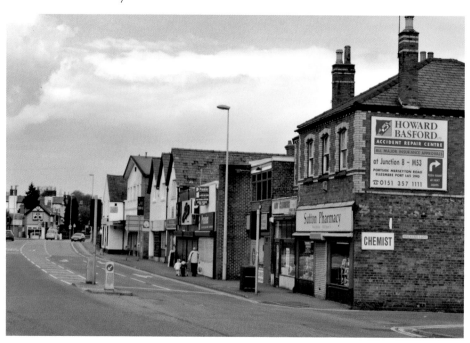

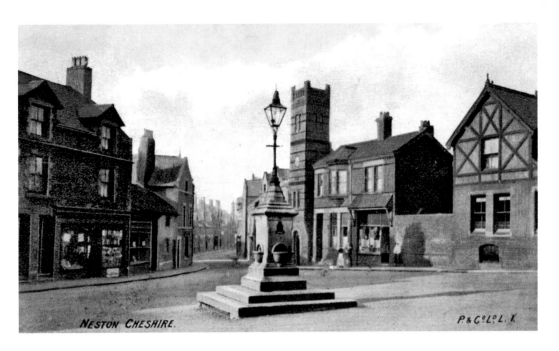

NESTON CHESHIRE.

P & Cº Lº L. X.

Neston c. 1900 & 2012

Our penultimate stop is Neston, once known as Neston-cum-Parkgate. The name originates from the Old Norse Nes-tun and it is in the Domesday Book as Nestone. Until the Dee silted up, cutting them off, Chester and Neston were major ports and as the silting progressed, nearby Parkgate took over. By the early eighteenth century, most port traffic had moved to Liverpool. Some say that the Liverpool Docks and Harbour Board took a hand in this by dumping their dredged spoil in the Mersey at a point where it would be carried into the Dee estuary!

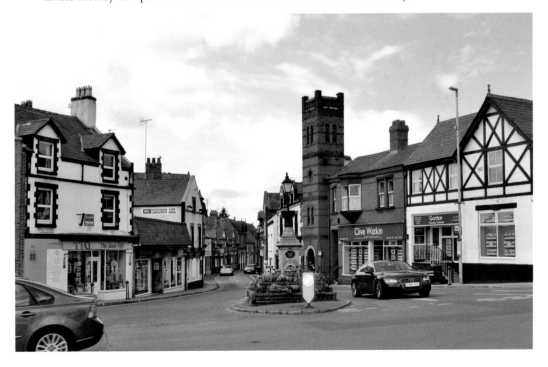

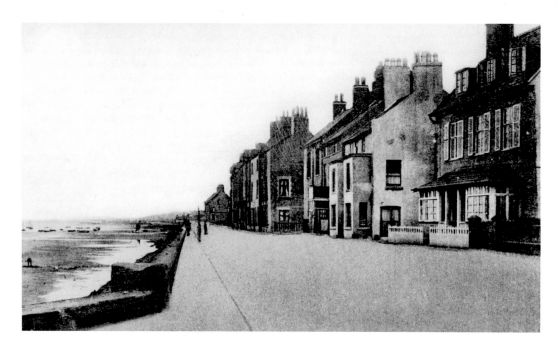

Parkgate Promenade *c.* 1910 & 2012

We have reached the far reaches of Cheshire now having started in Disley. Parkgate with its promenade, but now no water, stands on the River Dee estuary! It was once an important port in its own right, especially when the Dee silted towards the port at Chester. Parkgate was the home of the Packet boats to Ireland, Handel awaited his ship here and Nelson's mistress Emma Hamilton came from nearby Ness and would bathe here. A popular holiday destination with golden sands and ships moorings, it is now a salt marsh wasteland all the way to Wales across the estuary.

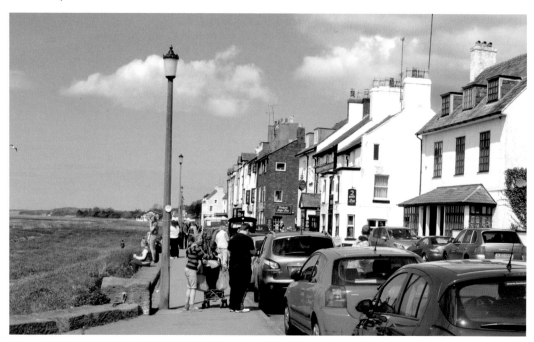